STREET FOOD

© 2011 Tandem Verlag GmbH
h.f.ullmann is an imprint of Tandem Verlag GmbH

Original title: *Streetfood. Authentische Snacks aus aller Welt*
Original ISBN 978-3-8331-5614-4

Concept and project: LiberLab, Italy (www.liberlab.it)
Texts: Carla Diamanti (www.carladiamanti.com)
Texts on China: Ilenia Parnanzone
Graphic design: Chiara Ricci, LiberLab, Italy
Layout: Chiara Borda, LiberLab, Italy
Cover: rincón2 medien gmbh, Köln (www.rincon.de)

Editorial coordination for h.f.ullmann: Lars Pietzschmann

© 2011 for the English edition: Tandem Verlag GmbH
h.f.ullmann is an imprint of Tandem Verlag GmbH

Coordination of the translation: LiberLab, Italy
English translation: Catherine Bolton for Koinè, Trieste (www.koine.eu)

Overall responsibility for production: h.f.ullmann publishing, Potsdam, Germany

Printed in China

ISBN 978-3-8331-5615-1

10 9 8 7 6 5 4 3 2
X IX VIII VII VI V IV III II I

www.ullmann-publishing.com
newsletter@ullmann-publishing.com

CARLA DIAMANTI

FABRIZIO ESPOSITO

STREET FOOD

AUTHENTIC SNACKS FROM AROUND THE WORLD

h.f.ullmann

Introduction 6

10 The Mediterranean

Water, yeast, and flour:
What comes out of the oven? 18
FARINATA (FLAT CHICKPEA FOCACCIA) 20
Kebab, *gyros* and *shawarma* 24
Olive oil, eggs, batter:
the Mediterranean array of fried food 26
Djemaa el Fna Square, Marrakech, Morocco 30
ARANCINI (FRIED RICE BALLS) 32
Tidbits 34
The Mediterranean Happy Hour 38
GRANITA 41
Mercado Central in Valencia, Spain 42
PAELLA 43

44 Europe

Potatoes? With fish, please! 50
SPRITZ 53
Donostia, Basque Country, Spain 54
The high-calorie world of sausages 56
BATTER FOR SWEET CRÊPES 59
GAUFRES OR WAFFLES 61

The *pretzel* story 62
SKILLINGSBOLLE (CINNAMON ROLLS) 64
CROQUE MONSIEUR 65
Roasted chestnuts and *vin brûlé* 66

68 Middle East

So many ways to say "good morning!" 76
WHITE COFFEE 78
KIBBEH (MEATBALLS) 81
The welcome coffee of the Bedouins 82
Flatbread, meat, and vegetables: the Syrian tradition 85
Mahane Yehuda and the Damascus Gate,
Jerusalem, Israel 88
BAKLAVA 89
Dried fruit and nuts in a bag, fresh fruit in a cup 90
Iftar and *Shabbat* 96
ARABIC BREAD, CHALLAH 97

98 Far East

The culinary mosaic of Malaysia 104
NYONYA KUIH PIE TEE 106
The culinary mosaic of Japan 108
OKONOMIYAKI 110
Bento 111

Contents

Cherry trees and picnics 112
Indonesia's "five feet" 114
SATAY 116
The streets of Bangkok, Thailand 118

120 Chindia

Street food in India 124
Bollywood, Mumbai, India 126
Samosas and *pakoras* 128
PAV BHAJI 130
CHAPATI 131
Street food in China 132
Youtiao: Chinese breakfast 134
Wang Fu Jing (Wangfujing Market), Beijing, China 136
Street snacks: *baozi, jiaozi, mantou* and *bing* 138
Sweet potatoes baked over coals 141
BAOZI 142
DRAGON'S BEARD CANDY 143

144 America

Hot dogs and pretzels 150
BLUEBERRY MUFFINS 154
CHOCOLATE CHIP COOKIES 155
Coffee and donuts 156

Quebec, maple on ice 159
New York, Philadelphia, Boston, USA 160
The world of corn 163
CORN FRITTERS 164
Street food or underground food? 166
PÃO DE QUEIJO (CHEESE BUNS) 167
¡Lloren chicos! 169
BANAN' PESÉ 170
Griot, piklis, banan' pesé 171
El día de los muertos, Mexico 172

174 Africa

SAMOSA 179
BROCHETTES 182
The culinary mosaic of South Africa 184
The Bamako-Dakar/Mali-Senegal train 186

Glossary 188

Photo credits 190

Authors 191

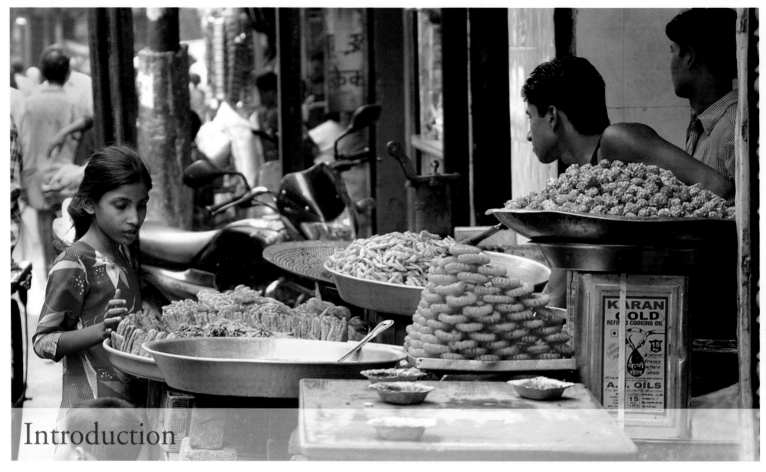

Introduction

There are thousands of ways to learn about world populations, discover cultures, traditions, and tongues, be enchanted by differences, and explore the unknown. A potential starting point for this exploratory venture is the observation of the street as a social space. Streets have long been places of exchange and contact, the departure for every journey, the link between the familiar and the unknown. In the past as well as today, the streets of a place that is new to us can tell us a great deal about its people, its culture, and its religious traditions. As a place of encounter, trade, communication, work, and leisure, the street often acquires a particular meaning.

Since the street is the stage on which we have chosen to view our world, the spectacle we have decided

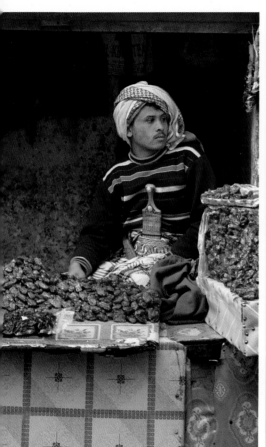

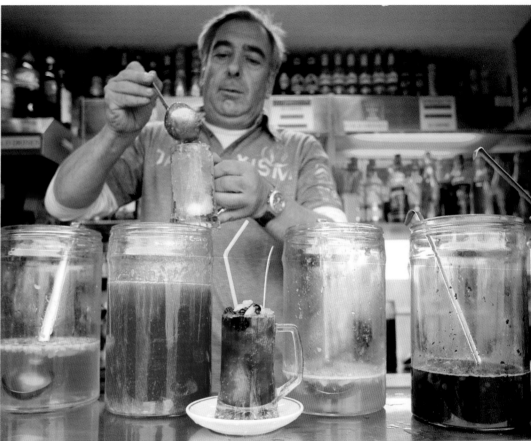

Stall in Delhi, India; the *souq* of the old city of San'a', Yemen; *grattachecca*, made of crushed ice and fruit juice, typical of Rome, Italy.

to watch is that of food. Food expresses the wealth or poverty of the land, eating habits and social rules; it filters religious discipline, underscores rites of passage, celebrates initiations, and finalizes agreements. Food is the expression of cultural identity at home and outdoors, standing or sitting, on the sidewalk or under a thatched roof, in the parks of New York or in the shadow of Tokyo's skyscrapers, on the sands of beaches or deserts. Our culinary voyage takes us around the globe to visit famous and less-known places alike. It has resulted in a mosaic of foods and habits, recipes and ingredients, traditions and places tied to food. Squares and cities famous for gastronomic delights represent the counterpoint to places where the street are the only possible way to pre-

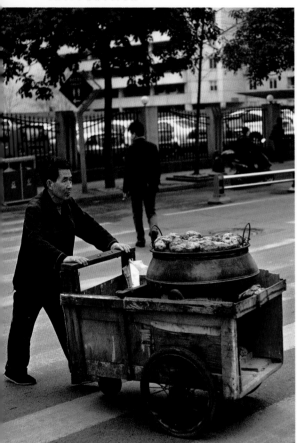

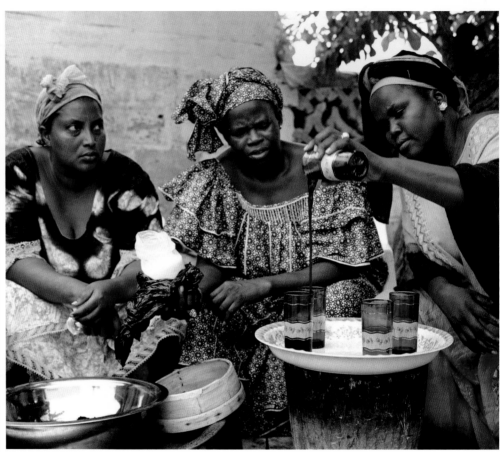

Chengdu, China: a typical cart with sweet potatoes cooked in a metal container; coffee with friends, Dakar, Senegal.

pare and cook food. Our exploration starts with the Mediterranean countries, where the sea is a vital source of nourishment for the people who live there. In Asia, we were fascinated by the colorful crowds at its markets and regional aspects, by customs and habits as different as they are entrenched. We dwelled on the traditions and culinary characteristics of the Arab and Jewish populations, and then headed to the bustling streets of Bangkok and on to Tokyo, Japanese cherry groves, and the intact traditions of the *nyonya* cuisine of Melaka. Our last stops in Asia were China and India: evolving universes, worlds within the world, escaping definition yet so clearly defined by their cultures. Our journey around the

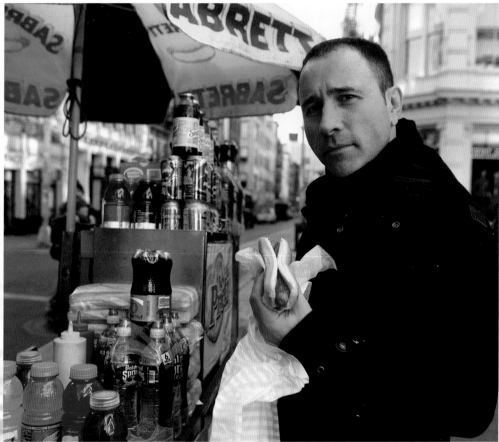

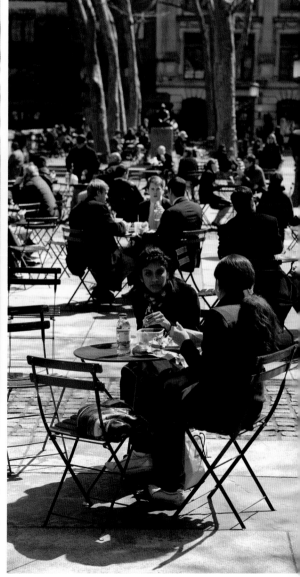

Hot dogs and soft drinks on the streets of New York; lunch break at Bryant Park in New York.

world ended in Africa and America. Both continents offer multifaceted vistas and an astonishing array of contrasts. The African continent has contributed abundantly to America, bringing it manpower, languages, rituals and music. Both of these continents have brought their mutual traditions to the street, revealing their most beautiful sides. Welcome to the richly laid table of the world. Welcome to its colorful streets!

The Mediterranean

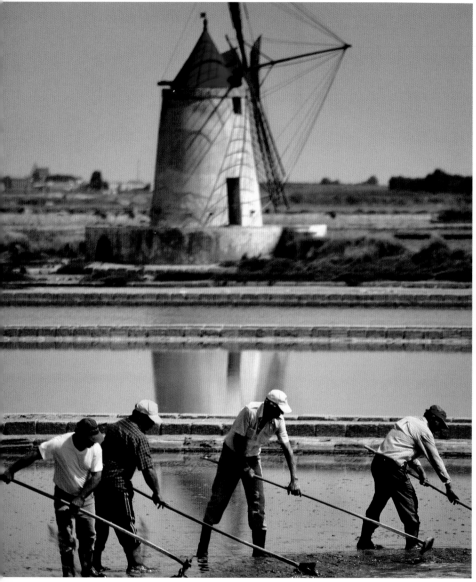

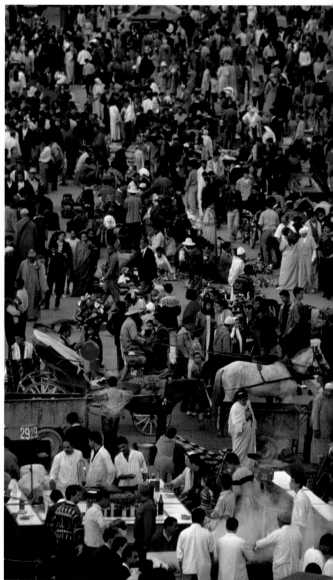

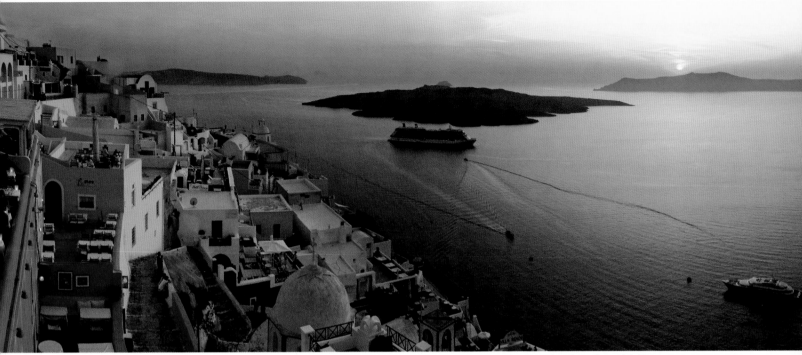

From p. 10: The market at Porta Palazzo in Turin, Italy; salt pans in Marsala, Sicily, Italy; Djemaa el Fna, Marrakech, Morocco; view from Santorini, Greece.

Two and a half million square kilometers, a myriad of islands, a mosaic of languages...

It is referred to as the "white sea" by the Turks and Arabs, though the latter also call it the "white middle sea", whereas the ancient Romans, who conquered vast territories along its shores, named this "inland" sea *Mare Nostrum*: "Our Sea".

Mediterraneus, the sea in the middle of land, is a universe of extraordinary beauty. Encircled like a lake, it extends — finger-like — into different lands to distinguish their climate, agriculture and the warmth of their people, constantly changing name.

It unites rather than separates. In a certain way, anyone overlooking the Mediterranean feels like part of a family.
It may be because of the sun, or perhaps it is due to the long history of contacts between its shores, from the first timid explorations

Falafel stand at the market in Shibam, Yemen; kiosk at the Parco del Valentino in Turin, Italy.

to conquests and trade. It is unquestionably due also to the fact that these lands have shared everything that was — and is — shipped on these waters, often from distant lands and transported over seemingly interminable routes: purple dye, silk, ointments, perfumes and even the alphabet. Above all, however, its shores were once the sole destination of spices, for it was from here that they reached courts and markets, where they were presented as precious rarities and rapidly shaped local diets.

The signs of fusion are endless: enclosed between the Dardanelles and Gibraltar, the area unites Europe, Asia, and Africa, which are bathed by the Mediterranean and communicate thanks to its waters. The mild climate facilitates encounters and human

 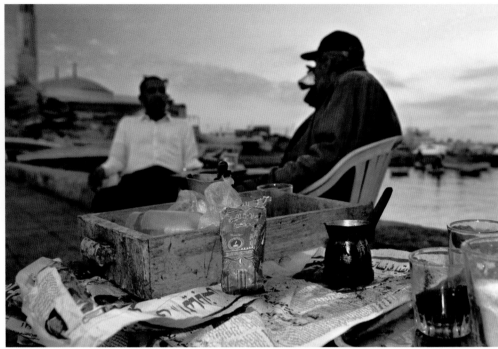

A sandwich before departure from the Rome train station; Alexandria, Egypt: coffee vendor; Djemaa el Fna, Marrakech, Morocco: snacking on snails.

contact, beckoning people to enjoy the outdoors and share lifestyles and habits. Likewise, food has invaded the streets and turned them into sublime settings.

The Mediterranean coast is unquestionably the stage for a *plein air* culinary spectacle that represents a true cultural legacy inherited from centuries of outdoor living.

From Africa's northern shores to the western boundaries of Israel, Lebanon, Syria, and Turkey, and on to the jagged coastlines of southern Europe, food tells the stories of immigrants, seafaring populations such as the Phoenicians, the cartographers who attempted to plot its outlines, and the stubborn farmers who, further inland, transformed difficult terrains into bountiful vineyards.

Carried by the Greeks and Romans, and then by the Ottomans and Arabs, foods followed people and flowed from houses into the streets, where they left their indelible and ineffaceable mark.

Stalls with *koshari* and falafel in Egypt, kiosks with ice cream and *granita* in Italy, stands offering *pan bagnat* along the dazzling Côte d'Azur and sea urchins on the beaches of Sardinia, the ubiquitous pizzerias, stalls selling crêpes and *piadina*, and shops proffering countless fried specialties represent some examples of street food, which are part of the local color and are photographed at least as often as the most famous monuments.

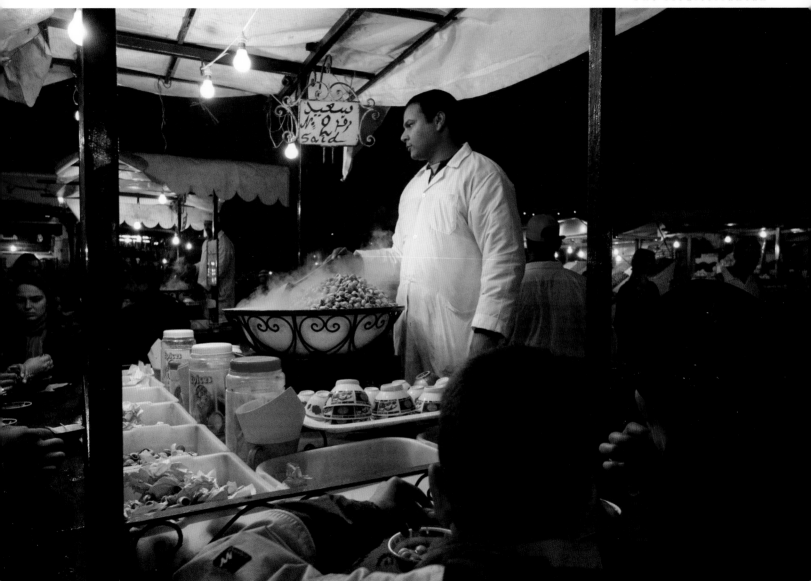

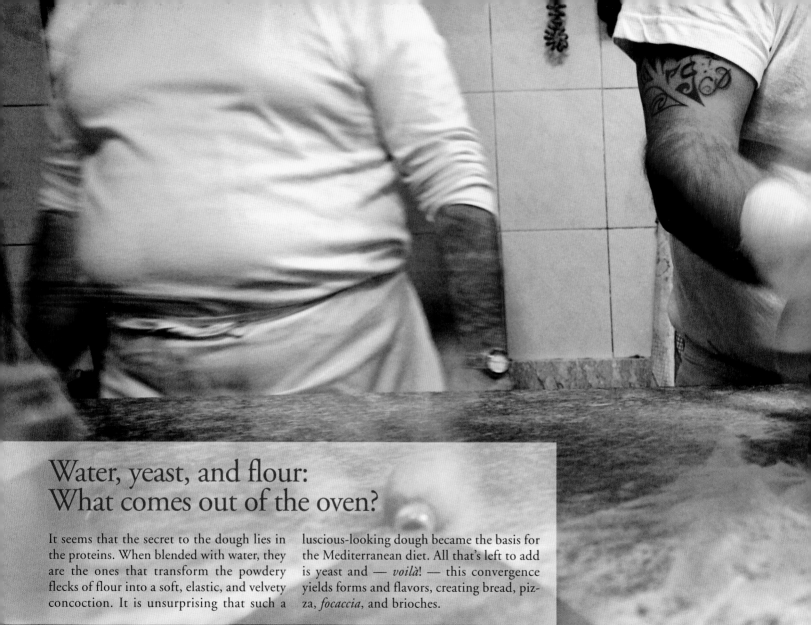

Water, yeast, and flour:
What comes out of the oven?

It seems that the secret to the dough lies in the proteins. When blended with water, they are the ones that transform the powdery flecks of flour into a soft, elastic, and velvety concoction. It is unsurprising that such a luscious-looking dough became the basis for the Mediterranean diet. All that's left to add is yeast and — *voilà*! — this convergence yields forms and flavors, creating bread, pizza, *focaccia*, and brioches.

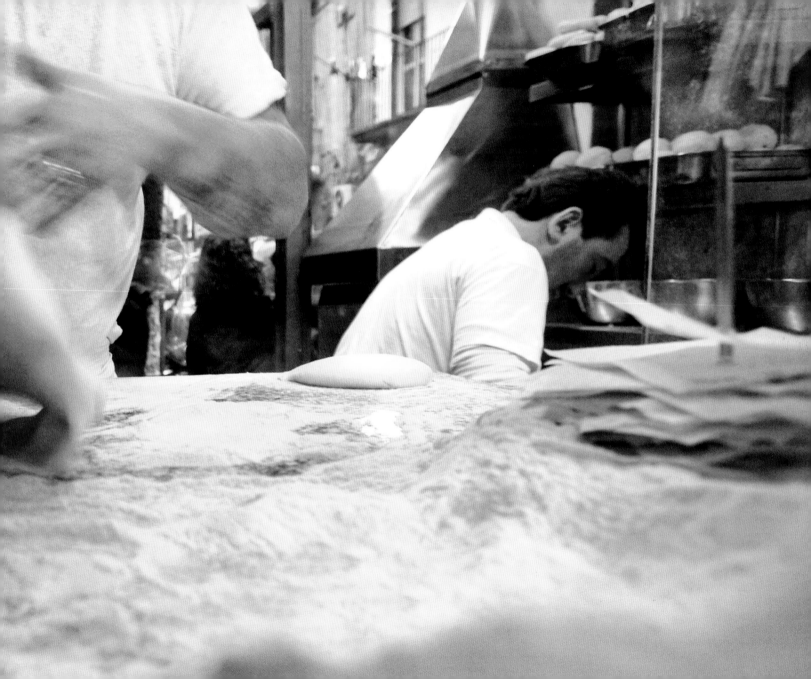

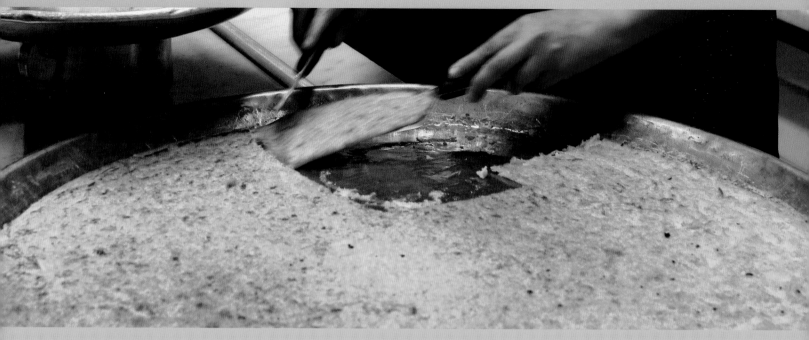

Farinata (flat chickpea focaccia)

This specialty originated in Genoa but has spread to many other Italian regions. According to legend, it was invented by accident in the 13th century when the barrels of oil stocked in the hold of a ship spilled onto bags of flour during a storm. Seawater moistened the mixture, which was left in the sun to dry and became the only food available to the starving sailors.

Ingredients (serves 4):
2 1/3 cup chickpea flour, 4 1/4 cups water, 1/2 cup extra virgin olive oil, salt and pepper

Put the flour and a pinch of salt in a bowl, and then slowly stir in the water. Add the oil and then set the batter aside for 4 to 12 hours. After the batter has rested, use a skimmer to remove any foam that has risen to the top and stir the batter again. Grease a large shallow pan — a round one is traditionally used — and pour in the batter. Bake for 20 minutes at 425° F. The *farinata* is ready when the top is crisp and golden. Serve hot with some ground black pepper, or with thinly sliced lard, ham or cheese.

From p. 18: Making pizza dough in Italy is the stuff of masters and sometimes calls for acrobatic skills; all types of fried foods are sold to hungry passersby in the streets of Naples.

The fragrance of things baking in the oven wafts through the squares and alleys, and floats into the streets from the tables of countless restaurants and eateries, enriched by the scent of tomatoes and vegetables, mozzarella, olive oil, meat, and fish to form a culinary extravaganza that relies on regional and typical local products. Flour, water, and yeast immediately evoke the queen of the oven: pizza. By the slice or served on a plate, plain or stuffed, with a thick or thin crust, or with a puffy edge called a *cornicione* — a thick edge encircling it — Italian pizza has spread across the globe, acquiring different nuances and flavors. But the street experience is a must above all in the alleys of Naples, where at all hours people line up in front of the windows of tiny pizzerias selling *pizza al portafoglio*. Unique among pizzas and unforgettable in taste, it is round and folded over — *al portafoglio* means "wraparound" — so you can eat it as you walk, without worrying about spilling anything. True Italian and Neapolitan genius!

As we move up the peninsula, the versions of pizza multiply. The basic dough is stuffed with mouthwatering tidbits inspired by the

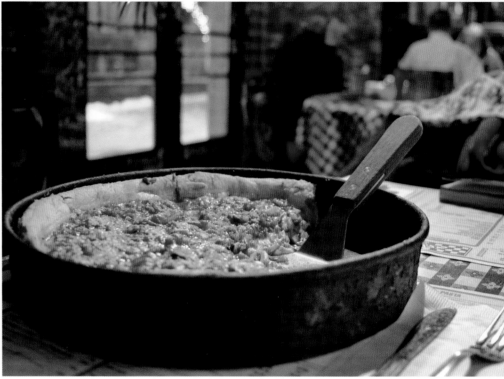

Baguettes and loaves of sesame, olive, and whole-wheat bread at a market in southern France; *pan pizza,* with a thicker dough and more toppings.

terroir. *Pizza al taglio* — by the slice — is made on huge baking sheets and then cut into rectangles to be served on a napkin, ready to be eaten in the street. The only delightful difficulty lies in choosing among the countless versions that are offered. Given the array of toppings such as tomato, mozzarella, anchovies, olives, tuna, grilled vegetables, frankfurters, and cold cuts, even the most discerning patrons are spoiled for choice. In Genoa the local specialty is called *focaccia.* White and about an inch thick, it is dressed with just olive oil and coarse salt. Although it is delicious at any time of the day, it is best in the morning on the way to school or work; at that hour, some even enjoy it with a cappuccino. The nearby town of Recco has even given its name to its own version, made without yeast but filled with *crescenza,* a soft cheese. *Focaccia di Recco,* with the cheese spread on top or between two very thin layers of dough, is enjoyed piping hot — but cautiously, to avoid dripping the *crescenza.* When *focaccia* is rolled out very thinly, it is called *piadina,* the most famous street food of the region of Romagna. Possibly invented in the Apennines, this specialty was brought

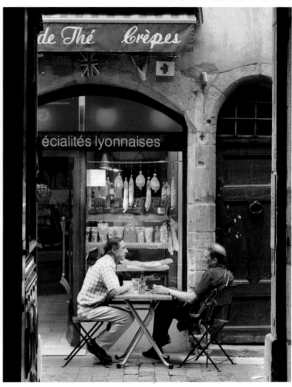

A Romagna-style *piadina* enjoyed outdoors in Bologna, Italy; view of an outdoor crêperie in Lyon, France.

from the mountains to the plains and has spread to many Italian cities. Stuffed hot or cold (delicious with ham and cheese), it has conquered streets as well as the menus of informal eateries, which are packed during the winter, when *piadina* is served with a good glass of red wine.

Above all, however, flour, yeast, and water mean bread. And where else but Paris has bread become an iconic street food? Stuffed baguettes are a noontime rendezvous for Parisians and tourists from around the world, who can choose between the basic version with brie and the kind filled with tuna, tomatoes, hard-boiled eggs, and *salade*, the ubiquitous lettuce leaf. Spread with butter, the baguette goes exotic stuffed with shrimp and avocado.

How do you find the best ones? Look at the lines at the *boulangeries*. The most famous have turned the baguette into a fashion phenomenon!

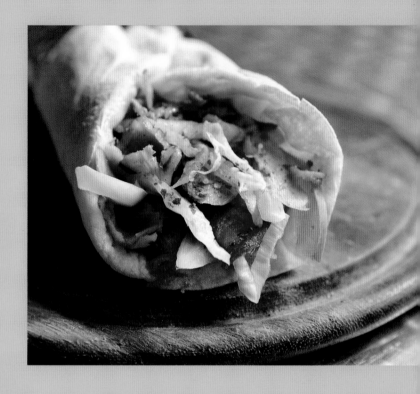

Kebab, gyros and shawarma

The Middle Eastern response to Western fast food has advanced inexorably ever since, in the 1970s, *döner kebab* landed on the Old Continent; Turkish cuisine had already arrived with the Ottoman Empire. Slices of veal, lamb or chicken, marinated in spices and placed on a vertical skewer that turns slowly in front of a red-hot grill, are stuffed into pita pockets or pieces of bread, rolled up with onions and tomatoes. And, naturally, the vendor adds to the atmosphere with gestures and knowing facial expressions. The basic ingredients are then accompanied by sauces that vary according to the location. In Greece, where they are called *gyros*, the sandwiches are made with pork and seasoned with numerous spices. The varieties have multiplied, but according to legend all of them originated with the soldiers in the steppes of

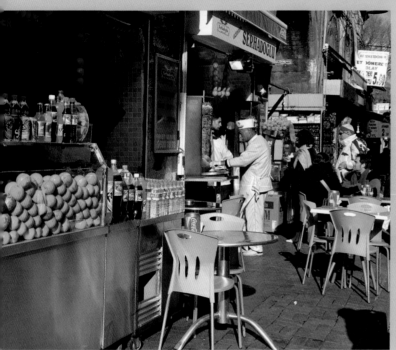

Central Asia, who would slide pieces of meat onto their swords and then cook them over the fire. Before they became "fast food" in Turkey, these rolled-up sandwiches were called merely *kebab* (with chunks of meat) or *shish kebab* (with ground meat), placed on a skewer, grilled with vegetables, and served on a plate covered with a piece of bread. In Turkey they're eaten at stands called *imbiss* (from the German word from "snack"), but if you ask for a *kebab* on the south-eastern shores of the Mediterranean what you'll get is an elongated meatball. That's because here those meat sandwiches are called *shawarma* and are accompanied by *tahini*, or sesame paste, and served wrapped in paper. In Damascus, you'll find the best ones around Bab Tuma, the city's Christian area, whereas the title of European capital of *döner kebab* goes to Berlin.

Olive oil, eggs, batter:
the Mediterranean array of fried food

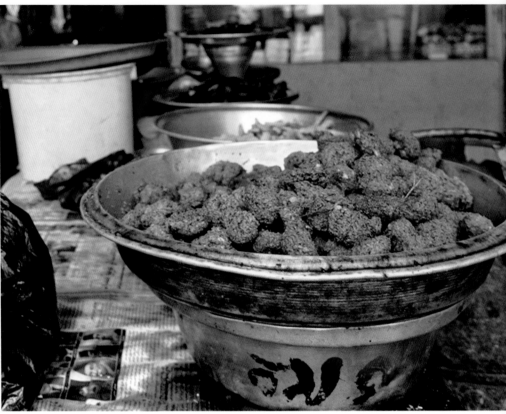

From p. 26: The oil-making process at a mill in Tourtour, France; fried potatoes, shrimp, and falafel: fried snacks to pass the time.

Delicious and fragrant, fried foods are simply irresistible. A stroll through Campo de' Fiori, in the heart of Rome, wouldn't be the same without a piece of *baccalà* — fried salt cod — or a zucchini blossom stuffed with mozzarella and anchovies. And, naturally, there are *arancini* and the iconic *supplì al telefono*, so called be-cause, at the first bite, the melted mozzarella stretches out in strands resembling telephone wires. Both are made with cooked rice and shaped into croquettes. The difference is that while *supplì* are oval and are made with toma-to sauce, *arancini* are round and can be stuffed with peas, but are white inside.

Fried foods are immensely popular on the other side of the Mediterranean as well, and the imagination is the only limit when it comes to these tidbits. In the alleys of the popular market of Khan al Khalili in Cairo, delicious falafel is fried and served in *khobz*, unleavened Arabic bread.

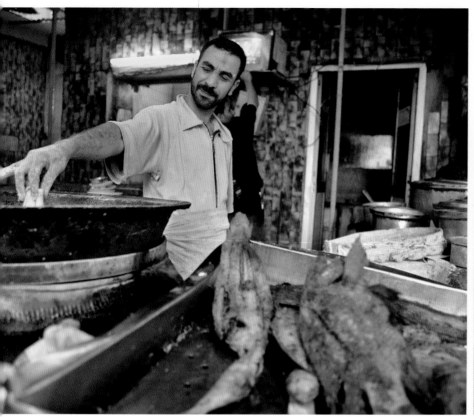

Fried fish in Alexandria, Egypt; various forms of rice *supplì* for passersby in Naples, Italy.

The Egyptian version, the *ta'miyye* in the local dialect, is a flattened ball made from fava beans mixed with parsley, as opposed to the dough for its Lebanese, Israeli, Palestinian, Jordanian, and Syrian cousins, made with chickpeas. In both cases, however, the preferred accompaniment is *tahini*, an eastern sauce made of sesame seeds. In Italy olives are also fried, in a typical specialty of the city of Ascoli Piceno, a city in the Marche region overlooking Adriatic.

The beloved green olive called the *tenera ascolana*, praised throughout history and even mentioned in literary works, is the key ingredient for this specialty, unquestionably one of the favorite fried foods of Italians.

The olives are pitted and then stuffed with a mixture of ground beef, pork, chicken, turkey, and Parmesan cheese. The olive is then sealed again, dipped first in egg, then flour and, lastly, breadcrumbs, and fried in boiling oil.

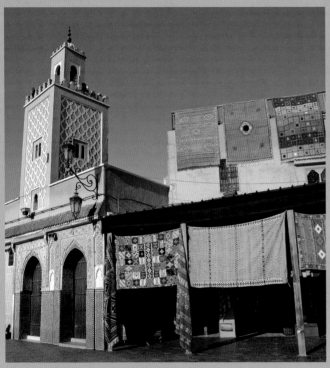

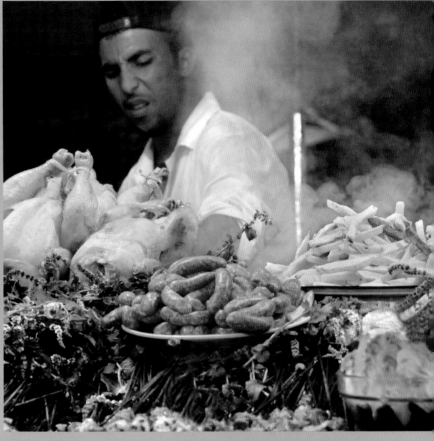

Djemaa el Fna Square, Marrakech, Morocco

The sight of the colorful crowd in Marrakech's most famous square is almost too beautiful to be real. The triangular outline of Djemaa el Fna, which in 2008 was listed as a "cultural space" in UNESCO's Masterpieces of the Oral and Intangible Heritage of Humanity initiative, evokes a world of story-tellers, snake charmers, and healers. Water sellers in their colorful garb are the first to invade the square and then come vendors squeezing oranges and grapefruits, but the pièce de résistance comes at twilight.

The lights turn on around the gazebos, cooks take up their skillets, and droves of hungry patrons crowd around the food stalls, as the smoke from roasting meat fills the square. Everyone beckons you to try their wares and there's no excuse. You simply need to stop. Standing or sitting, regardless of whether it's lamb's head or potato *brik*, the experience of an evening in Djemaa el Fna is unforgettable.

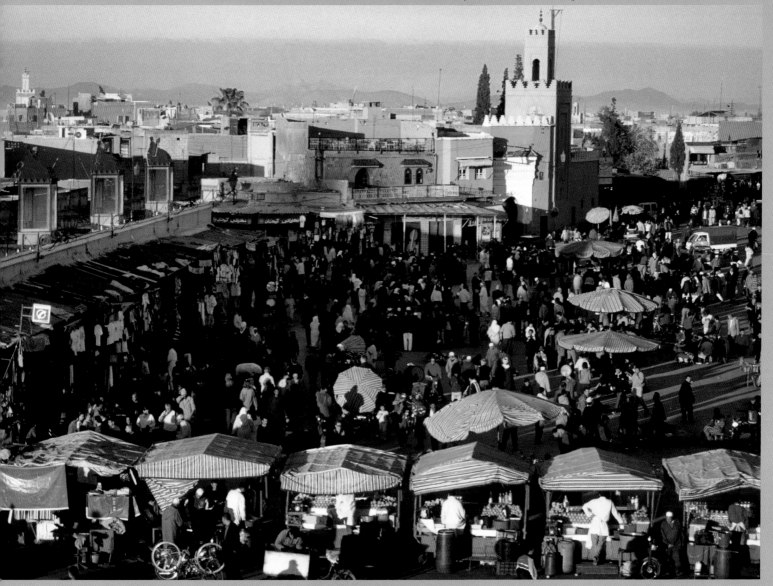

Arancini (fried rice balls)

Arancini have pride of place in countless Italian delis. These fried rice balls are one of Italy's favorite street foods, as an ideal light lunch in summer or to warm us on a chilly winter day. Prepared at home, they are a wonderful and tasty way to use up leftover rice.

Ingredients (makes 15):
2 1/3 cup rice, 1 7/8 cup Parmesan cheese, ground meat, 1 onion, 1 cup peas, 1 cup tomato purée, 1 1/4 cup cheese, 3 eggs, 3 1/3 cup breadcrumbs, extra virgin olive oil, frying oil, salt and pepper

Blanch the peas. Prepare a sauce with a drizzle of extra virgin olive oil, the chopped onion, the ground meat, the tomato purée, and the peas. Simmer for 30 minutes. Boil the rice in salted water and drain when done. Stir in the grated Parmesan cheese and an egg. Blend well and then roll the rice into balls of the size of a small orange. Create a hollow in the middle and fill with a spoonful of sauce and some cubes of cheese. Fill the hollow with more rice. Roll the balls in the beaten eggs and then in the breadcrumbs to coat. Fry them one at a time in a small deep pot. Serve hot.

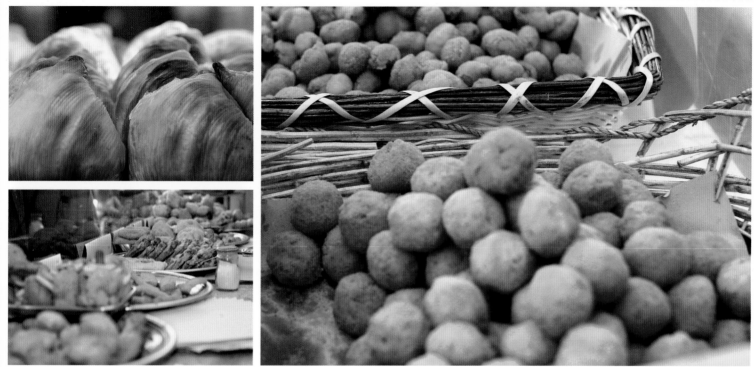

An extravaganza of sweet and savory fried foods: *sfogliatelle* and other tidbits at a Neapolitan fried-food shop, and *olive ascolane* with different fillings.

On the street, *olive all'ascolana* are wrapped up in a cone of straw paper, but they also appear on appetizer dishes. They are often served with another finger-licking specialty that is much easier to make: *pasta cresciuta*, at which the Neapolitans are true masters. Head up to Posillipo, the part of Naples up on the hillside, when it's time for an afternoon nosh and you'll see long lines in front of the fried-food shops. Flour, yeast, water, and a bit of salt are all it takes, and the balls of dough are ready to be transformed into fragrant fritters, served in a paper cornet with a sprinkling of salt. If you want to try the sweet version, you need to wait until Christmas, when Naples offers *zeppole*, a sugary variety. Otherwise, you can head to the Adriatic arm of the Mediterranean and walk through the alleys of Venice, filled with the warm smell of *fritoe*, a classic during Carnival, or the narrow streets of Croatia's small harbors, where they're called *fritule*. These sweet fritters are made of raisins, pine nuts, vanilla, brandy, lemon zest, and a pinch of nutmeg.

Our journey into the world of fried foods ends on the Spanish coast with savory *croquetas*. These cylindrical croquettes are made of béchamel mixed with ham, shrimp, vegetable, chicken or squid, and they are served as tapas at cocktail hour.

Tidbits

Patience and a soft touch are the key ingredients for making good ice cream; summer fruit salad made with watermelon, peaches, apricots, strawberries, and cantaloupe.

The ice-cream man. From east to west, as soon as children see him they squeal in delight! If we were to ask people around the world what they associate with this sweet concoction, the answer would invariably be the classic ice-cream truck.

It is usually white and has big wheels, an open umbrella, and tubs filled with all sorts of luscious soft ice cream.

The world of sweet street snacks thus bows to its king, the favorite and most famous way to cool off on hot summer days.

When out and about soft, light ice cream — fruit-flavored, chocolate, vanilla, and countless other flavors — is enjoyed in a crisp cone or paper cups. But since 1935, the year Domenico Pepino invented ice cream *da passeggio* (literally, ice cream for walking), it is still also enjoyed on a stick, covered with a thin, crisp chocolate coating that conceals a vanilla interior. Sweet and bitter, black and white, it is because of these two colors that "chocolate-coated ice cream" is still known as a "penguin" in Italy.

Popsicles are also eaten on a stick and represent a more practical version of *granita*, made of water and syrup or fruit juice. Lemon *granita* is the classic version, but in Sicily, where it was invented, you can also

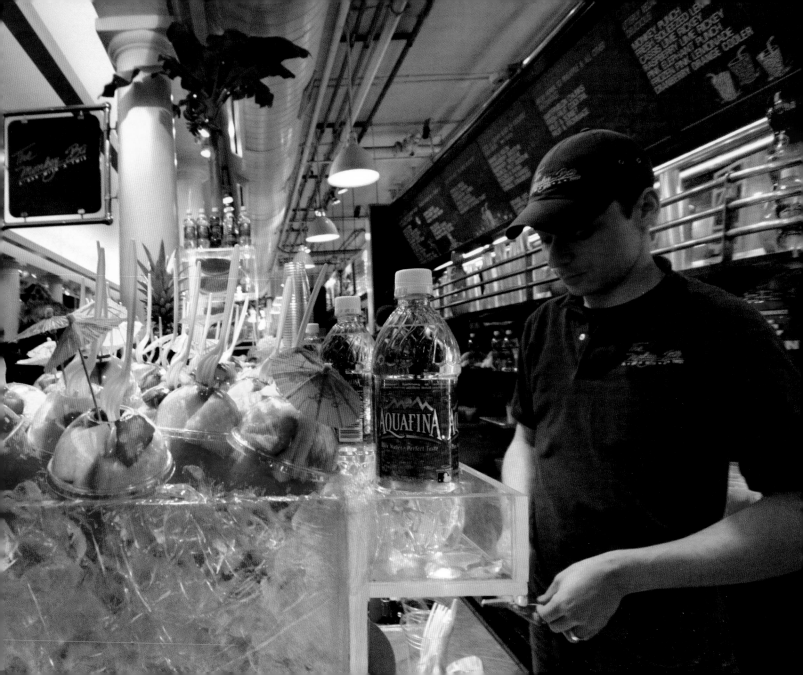

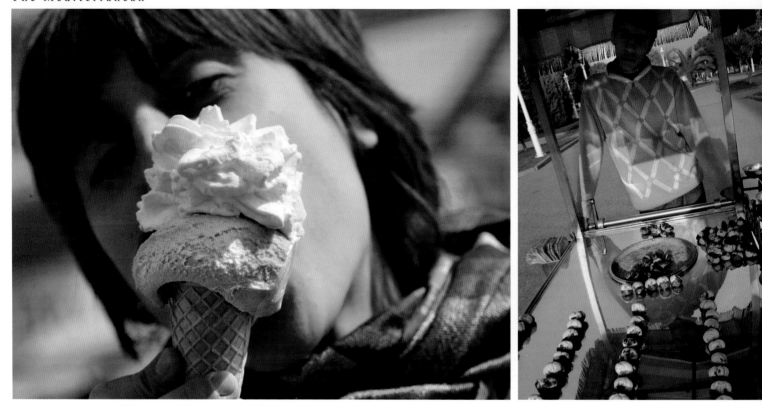

Cones in a wide variety of flavors symbolize summer in Italy, known for some of the best ice cream in the world; in autumn, people enjoy coronets of roasted chestnuts.

find almond, pistachio, black mulberry, and tangerine *granita*, served in glasses or the classic local way: in a *brioche*. Coffee *granita* with whipped cream is a Roman specialty. At the coffee shops of the historic district the lines are endless, but it is well worth the wait, as the reward is the extraordinary flavor of sweet cream mingled with that of bitter coffee. In the hot summers of the capital city, *grattachecche* — a less sophisticated version of granita, made of crushed ice served in a glass and covered with sweet syrup — is the perfect way to cool off.

On the other side of the Mediterranean, in the belly of the Damascus *souq*, ice cream is hand-whipped in deep aluminum containers. Showmanship is guaranteed and the frosty, dense cream is served in cones or plastic cups and then, with a touch of mastery, rapidly rolled in crushed pistachios.

The result? Exquisite!

Spain's characteristic street food has crossed the ocean as far as Mexico, where it has happily been combined with chocolate to bring

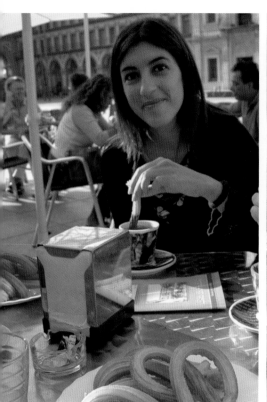

Churros and hot chocolate: a perfect combination for a break in Spain; shakes are the perfect way to cool off on a hot summer day.

out its full flavor, particularly when, piping hot, it is dipped into a steaming cup of cocoa. We're talking about *churros*, sold at stalls in the squares, streets, and markets of Spain. The dough, made of flour, sugar, oil, and salt, is put into a pouch and then squeezed out into long fluted shapes, ready to be fried in plenty of oil. Dusted with confectioner's sugar (but only if there's no hot chocolate around for dunking), *churros* are perfect any time of the day, the ideal energizing snack at sunrise after a night of festivities.

The season may have changed and winter arrived, but children still dash towards a cart. This time, however, it's not selling ice cream but pink or white cotton candy.

The spectacle is pure magic: wide-eyed children intently watching the rotating bowl and the mastery of the producer's arm, which transforms a wooden stick into a sweet gossamer cloud. The sugar sticks to your face, to the delighted giggles of youngsters accompanied by their parents, who instead prefer of paper cone with roasted chestnuts.

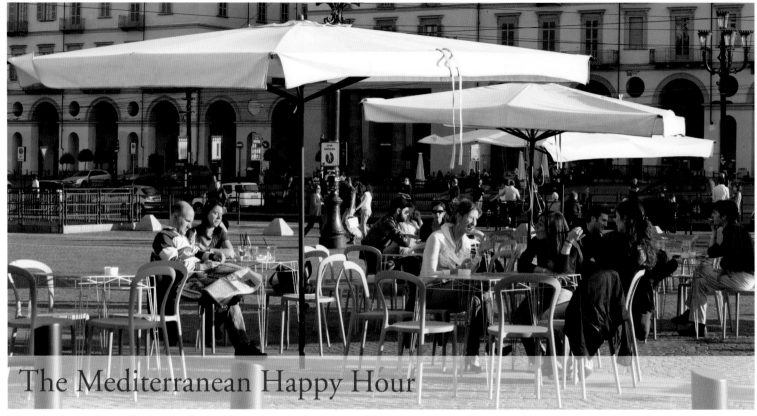

The Mediterranean Happy Hour

Happy hour is a rendezvous for the young and not-so-young, and habits change in different cities and countries.

It's 7 p.m., so let the *movida* begin! In this two-hour interlude the sidewalks in front of bars and trendy venues are packed with young people . . . of all ages.

In many northern Italian cities, above all Milan and Turin, one of the most popular urban rituals is celebrated at this hour: the aperitif. It was in Turin that, over two centuries ago, Antonio Benedetto Carpano flavored wine with herbs and spices, inventing vermouth, a drink served in the evening with savory nibbles.

Those nibbles then multiplied into hors d'oeuvres laid out on huge inviting platters and became an early-evening occasion to eat standing outside the bar, sipping a cocktail. Pasta salads with vegetables, tuna, and corn; rice salad; slices of cheese bread with veggies; cold cuts and cheese; celery stalks served with olive oil and salt or stuffed with cheese; grilled vegetables and crudités.

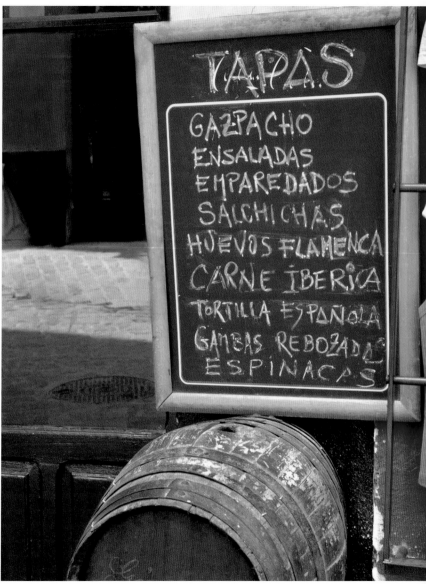

TAPAS

GAZPACHO
ENSALADAS
EMPAREDADOS
SALCHICHAS
HUEVOS FLAMENCA
CARNE IBERICA
TORTILLA ESPAÑOLA
GAMBAS REBOZADAS
ESPINACAS

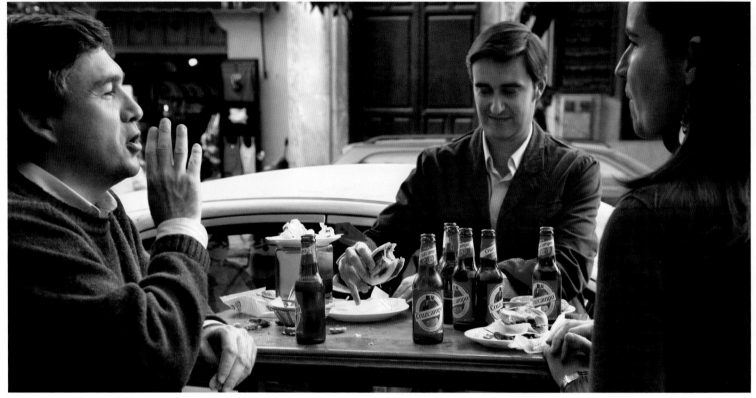

The outdoor area at a Spanish bar where customers, sitting at tables on the sidewalk, enjoy beer and tapas with various fillings.

Where the Mediterranean meets the Alps, where Italy and Austria converge, people instead prefer a good glass of wine and drink a toast with a *spritz*, another age-old recipe that has only two known ingredients: seltzer and the bartender's imagination.

Moving west, the days are a bit longer and customs tend to slide into the second half of the day. In Spain the tradition of *ir de tapeo*, i.e. wandering from bar to bar to enjoy tapas, extends far into the night, particularly in summer.

Originally tapas were just olives and peanuts served with a glass of wine.

Today they express the most unbridled imagination and the trend has been exported, so that tapas are now served virtually everywhere. But why are they called *tapas*? The name derives from the lid that, in the 19th century, was set over the glass to protect it; the drinker would then place it under the glass when he took a sip.

As a result, it served as a saucer on which to place the accompanying nibbles.

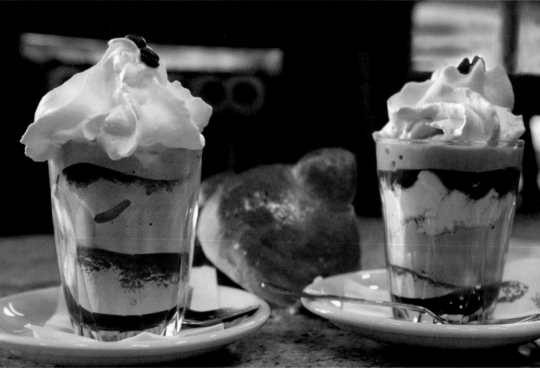

Granita

Coffee *granita* is one of the most popular summer street foods, famous above all in the heart of Rome, where there is fierce competition among bars to win the title of "Best *Granita*." However, there are variations in other Italian regions as well, such as the Sicilian lemon *granita*. One of the secrets to making it tastier is pouring a layer of cream on the bottom of the glass.

Ingredients (serves 4):
3/4 cup sugar, 2 1/8 cups water, 1 1/2 cups coffee, whipped cream

Boil the water and sugar to make a syrup. When the sugar has completely dissolved, add the coffee. Pour the liquid into a container and put it in the freezer for at least 2 hours. Stir the *granita* at regular intervals. Serve it in a tall glass with a dollop of whipped cream.

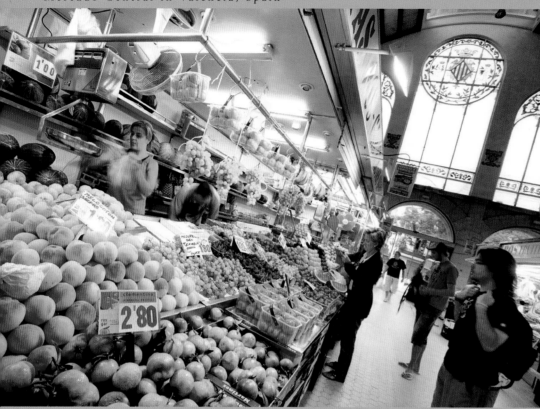

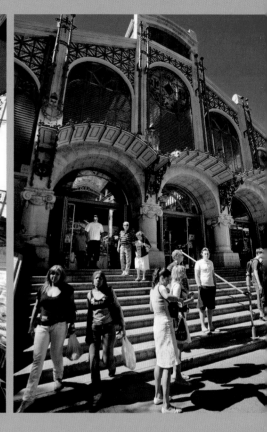

Mercado Central in Valencia, Spain

Valencia is a fascinating city, and not only for those who are passionate about art and culture. The homeland of paella and *horchata*, a refreshing drink made of water, sugar and tigernuts, and of an extremely popular cocktail called *agua de Valencia*, it is a city that loves outdoor living. As soon as the weather gets warm, crowds flock to the streets to eat and drink, taking advantage of the more than 8000 bars and eateries that fill the plazas and seafront. But the culinary offer is not complete yet, for in the very heart of town, next to the breathtaking Lonja de la Seda, is the Mercado Central.

With its steel structure, colorful windows, and beautiful tile façade, it houses 959 stalls that sell all types of fruit and vegetables, and the infinite variety of fish that, for centuries, the Mediterranean has offered this city and its people.

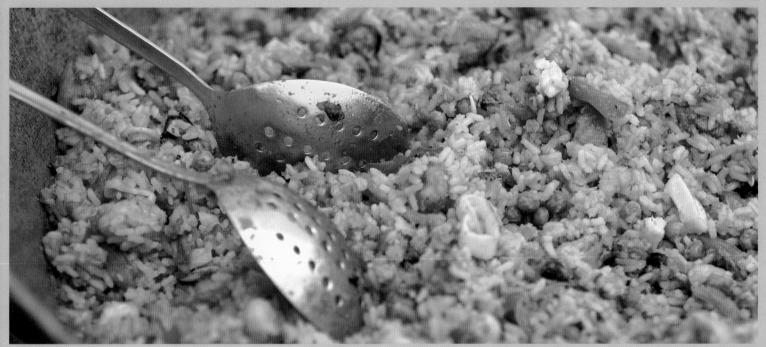

Paella

The most famous dish of Spain's Mediterranean coast has now become international, with the addition of fish, shellfish, and vegetables of all kinds. These ingredients are much more refined than the ones used centuries ago, when paella may have been invented as a way to use leftovers. Regardless of the variations on this theme, the key ingredient is the rice grown in the Valencian countryside.

Ingredients (serves 8):
2 7/8 cups short-grain white rice, 1 chicken and 1 rabbit cut into pieces, 14 snails, 3 cups green beans, 1 cup *garrofón* (lima beans), 2 artichokes, 1 tomato, 1 tsp sweet paprika, saffron, 1 cup olive oil, 6 1/3 cups water, salt, rosemary, 1 lemon

Trim and wash the green beans, the *garrofón*, and a tomato. Clean the artichokes, removing the tough outer leaves. Cut into wedges and remove the fuzzy choke. Heat the oil in a large skillet (an iron *paellera* is best). Brown the pieces of chicken and rabbit, and then add the green beans, the *garrofón*, the artichokes, and the tomato. Dissolve the paprika and saffron in some hot water, and then add them to the skillet. Salt and cook over a high flame for 15 minutes. Add the snails and, lastly, the rice. Add the water a little at a time. A few minutes before the rice is done, add the rosemary. Before serving, remove the rosemary. Rinse and slice the lemon, and use it to garnish the paella.

Europe

From p. 44: Fish soup is a way to warm up by the North Sea; a snack on a canal in Copenhagen; *frites* and mayonnaise in the snow in Brussels, Belgium.

In crowded streets and deserted squares, the "Old World" moves to the beat of contrasts and similarities.

In Europe cold winters alternate with long summer days, and the people head to the street above all at lunch or snack time: in winter to warm themselves with a hot drink from a street stand, and in summer when they want to eat outdoors as they bask in the sunshine.

With its marvelous interplay of simple ingredients and imagination, the varied cuisine of central-eastern and northern Europe has conquered streets and squares. It is an extravaganza of calories that can stand up to the winter chill, yet doesn't shut itself up indoors even on the coldest days. And with the first warm rays of sunshine heralding the summer, people head to the streets and squares to celebrate the most beautiful season under shimmering skies. Strong flavors characterize street food in winter, while in summer lightness prevails.

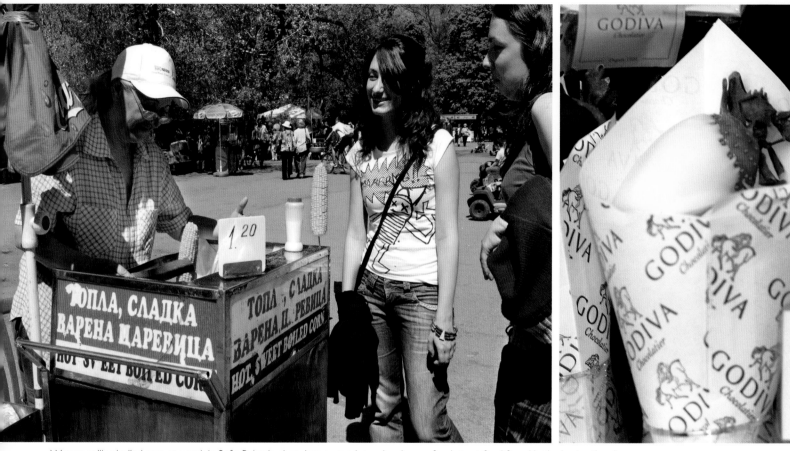

Woman selling boiled corn at a park in Sofia, Bulgaria; chocolate-covered strawberries: a refined street food found in the best patisseries.

In the coldest months plates are piled high with seafood and fish specialties, but when the mercury rises with the arrival of summer it's the fresh taste of berries — strawberries in particular — that tickles the palate. During the winter, the French serve seafood and fish with Calvados from Normandy and Brittany, the famous apple brandy distilled from fresh cider. This is also the season to enjoy the delicious array of local cheeses.

Fish and chips can unquestionably lay claim to being Great Britain's most famous street food. A cardboard box and a wooden skewer are all you need to enjoy these classic fish fillets, which are fried in a batter that can also

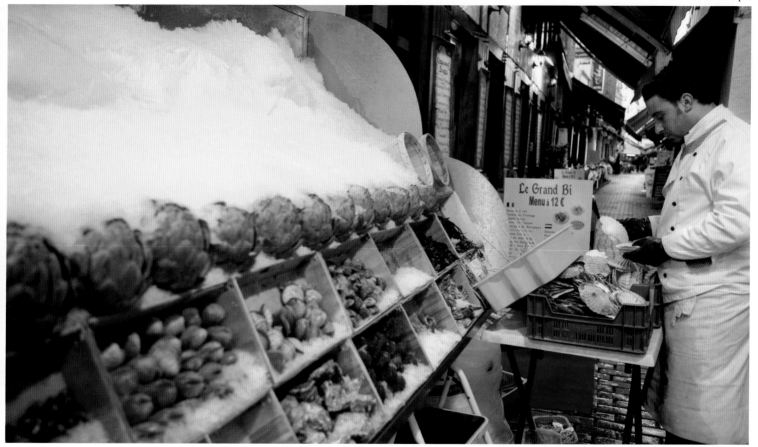

Mussels, oysters, and scallops at the old fish market in Brussels, Belgium (Halles du marchés au poisson), opened in 1884 in the square in front of the church of Sainte Catherine.

be made with a little beer or milk, depending on what strikes the cook's fancy. The flavor and golden color might change slightly, but not the success of this dish. All kinds of berries color European summers and bring the colors of painted wooden houses — red, green, and blue — to market stalls. People are well aware that the long summer shadows will soon be shortened and the summer gone, so fruit and produce are turned into inventive preserves. Cloudberries, blueberries, and raspberries are put into glass jars to accompany cakes during the winter, or can be found on tables as jams, sauces and more.

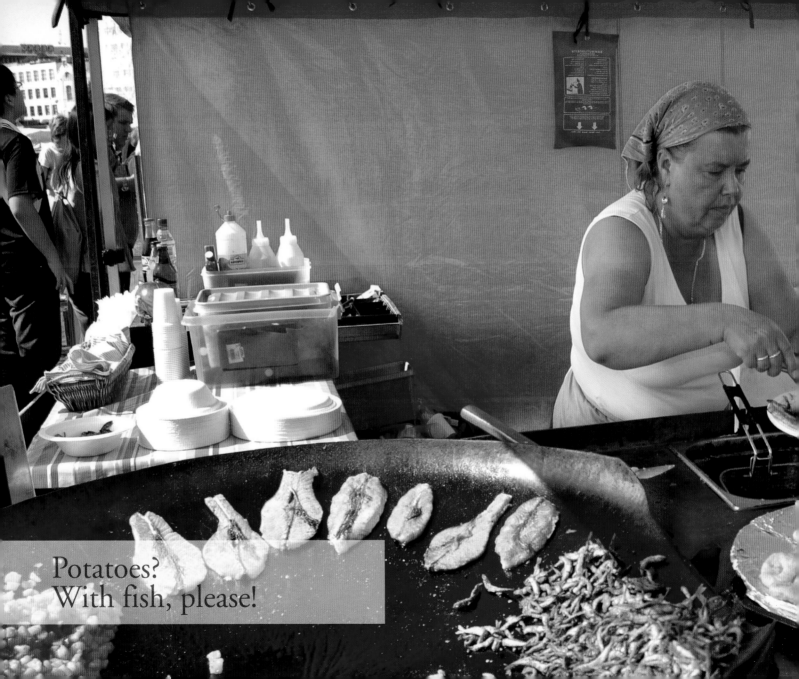

Potatoes?
With fish, please!

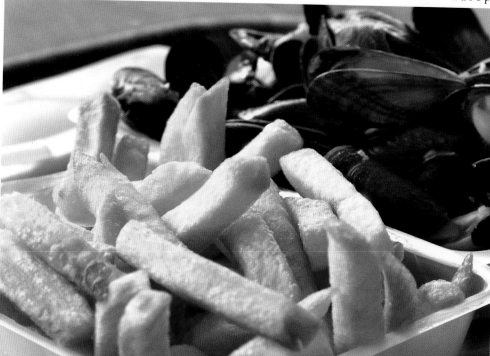

At Kauppatori, the market square in Helsinki, Finland, fish is cooked on the spot, with or without fried potatoes.

Potatoes and Central Europe share a long history. Brought over to Europe from the New World centuries ago, they have come to characterize habits and diet.

Let's take a look at Belgium. Cornets of *frites* with dollops of mayonnaise are the savory alternative to the ubiquitous *gaufres* (waffles) covered with sugar or chocolate sauce, and they have become the symbol of Belgium. Everyone knows that wherever you go around the world, potatoes lend themselves to exceptional culinary combinations.

The famous fish and chips are a perfect example. At every street corner in the United Kingdom there is a pub boasting that its fish fillets have the best batter.

The iconic British snack is still all the rage thanks to the fame of chippies, vendors who have even become organized in fast-food chains located virtually everywhere.

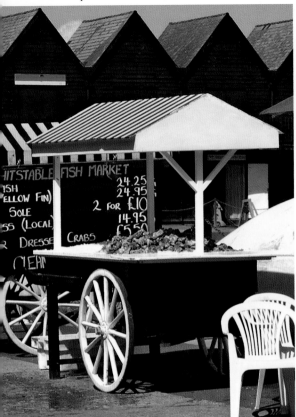
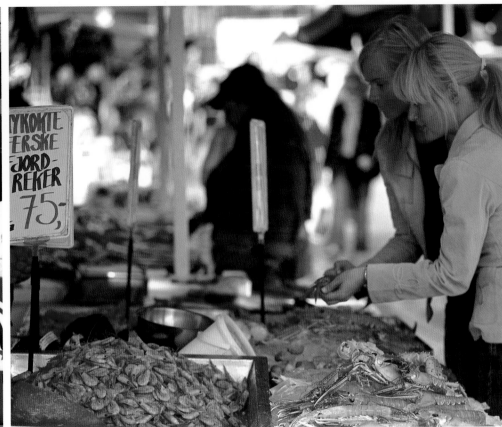

The Whitstable Fish Market in Kent, famous for its oysters, and the famous Fisketorget in Bergen, Norway, where salmon and shrimp reign supreme.

There is no question that the combination of chips or *frites* and fish is a culinary classic in Europe. But in northern Europe fish is a star all on its own. All it takes to grasp just how much the locals love fish is a morning stroll along the picturesque Bryggen, in the Norwegian city of Bergen, to see the Fisketorget, the famous fish market. The enormous quantities of seafood at the stalls entice Norwegians and visitors alike, who rendezvous here, camera in hand.

Fish is also sold along the streets of Normandy and Brittany. Or, rather, there is shellfish, which triumphs above all in the town of Cancale, touted as the oyster capital of northern Brittany. Wherever you go, you can hear the sound of oysters being shucked on the tables of countless restaurants to reveal their succulent sought-after treasure to customers enjoying a view of the sea.

Spritz A popular aperitif in Italy (above all in Triveneto area in the northeast), it is also known in Germany — called *Gespritzter or Weinschorle* — where the spirit used to make it differs from region to region.

Ingredients (serves 1):
1.35 fl oz Aperol, 2 fl oz *prosecco*, a splash of seltzer or club soda, ice, half an orange slice

Fill a large wine glass with ice. Add the *prosecco*, a splash of seltzer or club soda, and then the Aperol. Serve the *spritz* accompanied by half an orange slice.

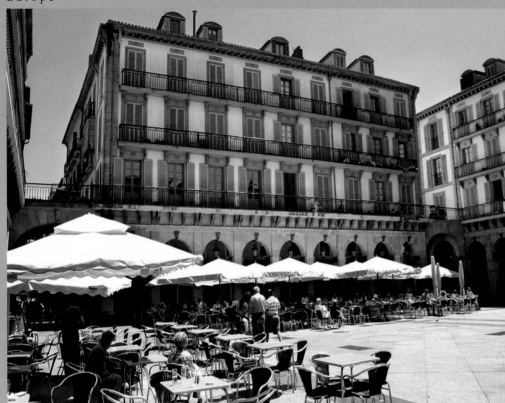
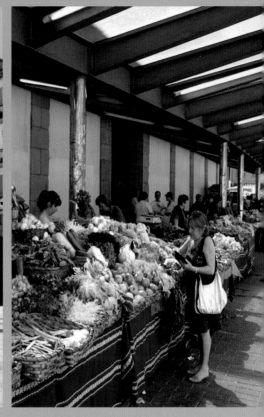

Donostia, Basque Country, Spain

Don't call it San Sebastián! Or, rather, that's not it's only name, because around here it's referred to as Donostia, strictly in Euskara, i.e. Basque, which is probably the Old World's most ancient language.

The streets of the Pearl of the Ocean welcome foodies who flock here from all over the world to discover the authentic face of Spanish cuisine. Tied to the local culture, the *cocina vasca* thrives on long-lived traditions, fish, and

miniature delicacies. The area is famed for its curious "men-only" cooking clubs, which are completely off-limits to women, who cannot participate in any of the preparations or sit at the tables, where men discuss politics and the

weather. And in the streets you can buy (and eat) fresh fish, which arrives from the nearby fishing villages. Nevertheless, the *txikiteo* is the height of epicurean pleasure on hot summer evenings.

It is a ritual of going from bar to bar to drink little glasses of wine, the *txikitos*, accompanied by delicious *pintxo*, minor culinary masterpieces that have inspired a "miniature cuisine" to be eaten in the street. Called *pinchos* in Castilian, they are named for the fact that initially the bread and toppings — ham, of course, but also cheese, fish, olives, *tortilla* and peppers — were held together with a toothpick.

The bars lining Plaza de la Constitución, where there are trays full of these irresistible appetizers, are *the* place to meet. But watch your wallet... even when it's mini-sized, good food isn't cheap!

In fact, Donostia is not only the culinary capital of *txikitos*, but it also happens to be the city with the world's highest concentration of Michelin-star restaurants.

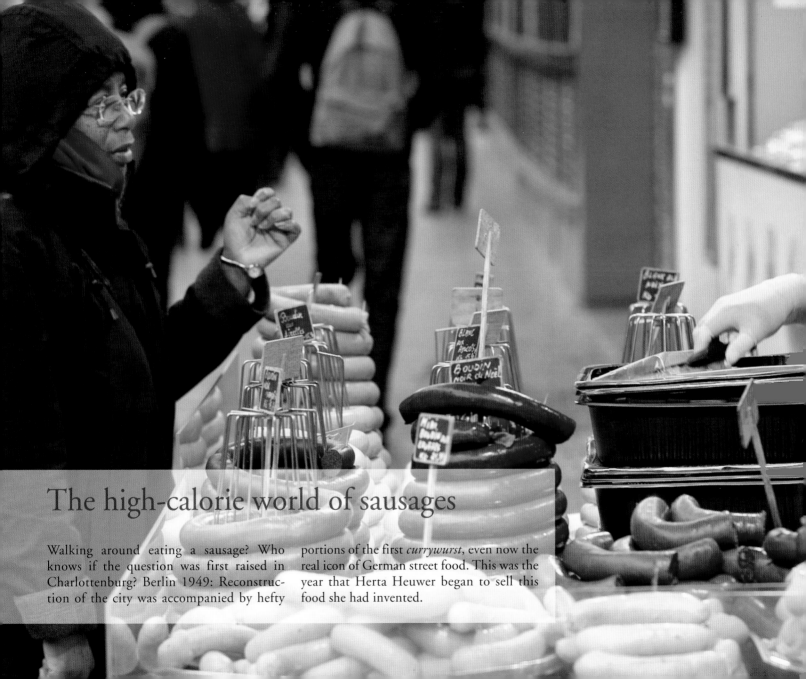

The high-calorie world of sausages

Walking around eating a sausage? Who knows if the question was first raised in Charlottenburg? Berlin 1949: Reconstruction of the city was accompanied by hefty portions of the first *currywurst*, even now the real icon of German street food. This was the year that Herta Heuwer began to sell this food she had invented.

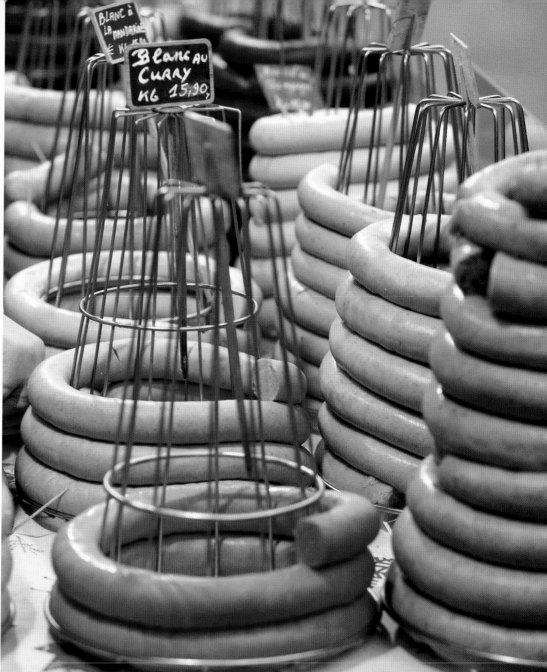

BLANC AU
CURRY
KG 15,90,

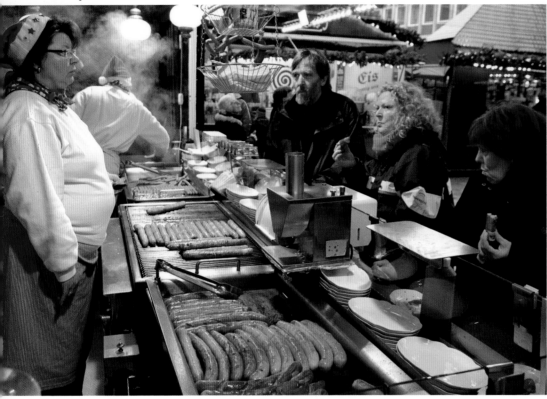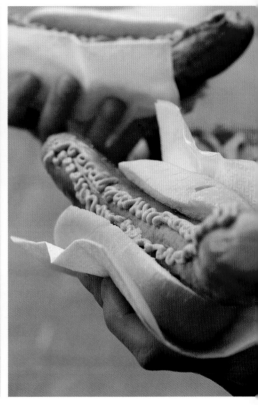

From p. 56: Sausages and hot dogs served with sauces and bread, icons even among the classics of street food.

It seems that it was created by accident, mixing various spices with ketchup, curry powder and Worcestershire sauce, and then spreading this concoction on sliced grilled pork sausages.

Currywurst became so popular that it inspired stories, movies and even a television series. In 2009, to celebrate the 60th birthday of the sliced sausage sold on street corners, the city of Berlin inaugurated the Deutsches Currywurst Museum: a true record and an honor reserved for very few culinary specialties.

A "virtual bridge" between Central Europe and the Balkans links Germany with Turkey. It seems that the Turkish city of Kayseri can lay claim to a specialty that reached Hungary and Romania, where it became known as *pastirma*. From there, Jewish immigrants brought it to the United States, where it is now known as pastrami.

Thin slices of this cured spiced beef are served at kiosks and restaurants alike, and it is now very widespread and appreciated throughout the Balkans.

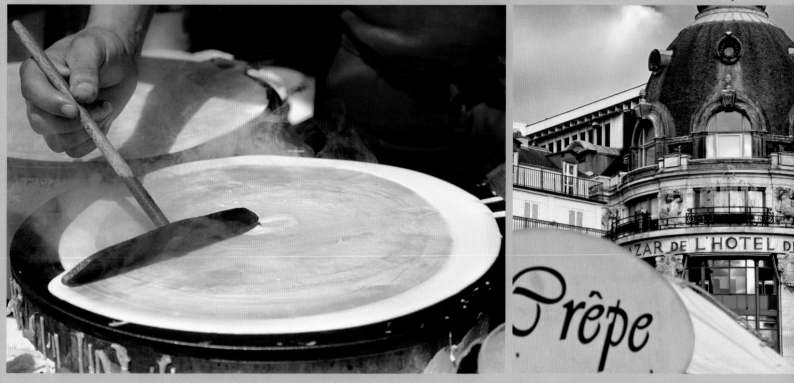

Batter for sweet crêpes
This feathery egg pancake, found throughout the streets of Paris and made with buckwheat in Brittany, accompanies strolls in many European cities. Filled with jam, chocolate or just a little powdered sugar, the crêpe has become a must and a true street-food classic. The savory version is also delicious, stuffed with ham and cheese — and excellent with a glass of cider.

Ingredients (makes 12):
2 cups all-purpose flour, 2 eggs, 2 cups milk, 1/2 cup powdered sugar, 1/4 tsp vanilla extract, 1 tbsp rum, butter, salt

Put the flour, sugar, and a pinch of salt in the bowl. Add the milk slowly, blending with a whisk until smooth. Add the eggs, rum, and vanilla extract. Blend and cover with plastic wrap. Set aside for at least 30 minutes. Grease an 8" nonstick round crêpe pan with butter. Pour in 3 tbsp of batter, swirling to coat the entire surface of the pan. Brown slightly and then flip the crêpe with a spatula to cook the other side. Slide onto a plate and continue until all the batter has been used, stacking the crêpes on each other.

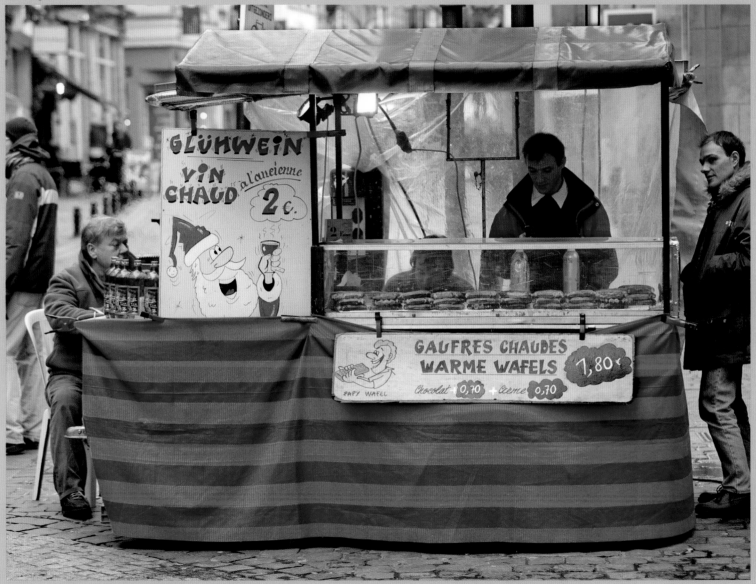

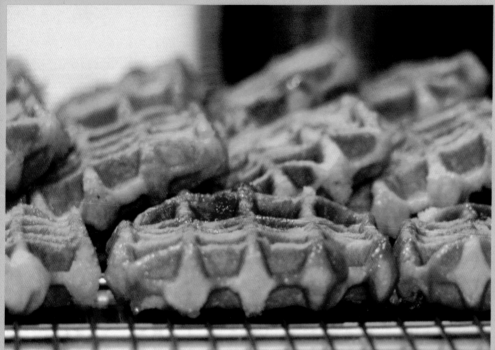

Gaufres or waffles
Dusted with powdered sugar, slathered with whipped cream, swimming in chocolate sauce or decorated with strawberries, the most famous *gaufres* are from Lieges. It seems that this specialty, popular throughout Belgium, was already known in antiquity, as the Greeks ate a sweet dish cooked between two red-hot metal plates.

Ingredients (makes 6–7):
2/3 cup flour, 3 1/3 tbsp sugar, 1/3 cup milk, 0.2 oz fresh active yeast, 1 egg, 2 tsp butter, powdered sugar, salt

Warm the milk. Put the yeast in a cup with 1/3 tbsp sugar and the lukewarm milk. Stir to dissolve the yeast. Put the flour, the remaining sugar, the egg yolk, and a pinch of salt in a bowl. Beat well. Slowly add the milk and yeast in a steady stream. Beat the egg white until stiff and melt the butter. Fold into the batter. Cover with a tea towel and set aside for 15 minutes. Heat the waffle iron (*gaufrier*). To make a 4-inch *gaufre*, pour 2 tbsp of batter on the iron and close. Cook for about 3 minutes. Repeat with the remaining batter. Dust the *gaufres* with powdered sugar or top with jam, whipped cream, ice cream, etc.

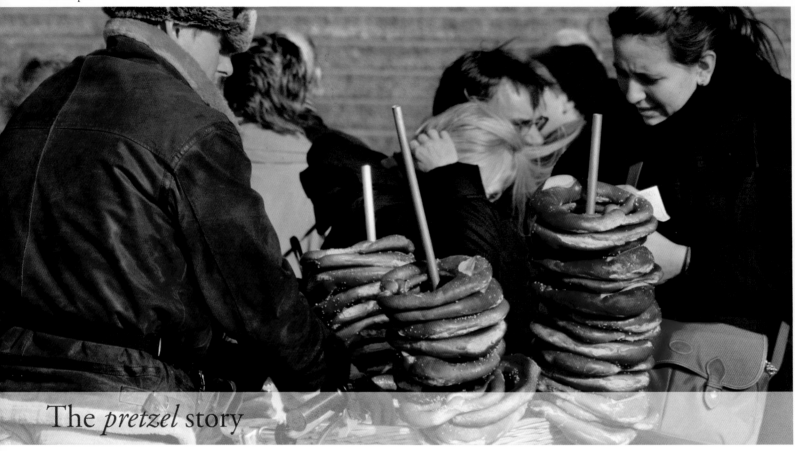

The *pretzel* story

Of the many accounts on the origin of *pretzels*, there are two that are especially fascinating. One is the tale of a prince and a princess who wanted to marry.

The other is about a monk who was compassionate towards diligent children.

The first legend is a love story about an indissoluble bond that became the symbol of fidelity and unity.

The second one talks about the *praetiola*, little rewards that monks would give to children who learned their prayers.

The name of this popular snack seems to derive from the latter.

Enjoyed at all hours, *pretzels* are piled into huge wooden baskets and hawked in the street, covered with coarse sugar and displayed in bakery windows, and — in the

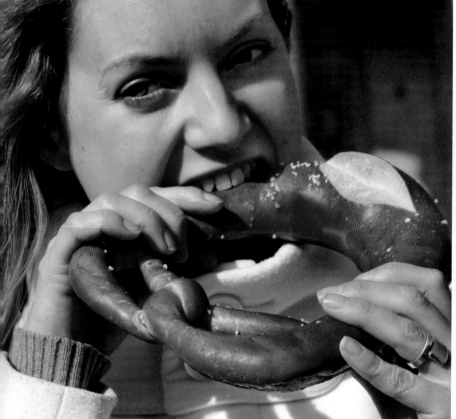

In front of the Reichstag, Berliners and tourists buy *pretzels* to battle the cold. The sweet and savory versions of this specialty are very common in German-speaking countries.

salted version — sold at bread shops. Hard and soft *pretzels*, invented in Italy or possibly France, spread from there to Germany where, starting in the 14th century, they were depicted on the signs of bakers' shops. Also known in Switzerland, Hungary and Austria, they were introduced to the United States of America in the 19th century.

In both shape and ingredients they clearly spark the imagination.

The former has been thought to evoke the Holy Trinity or pagan fortune because of its resemblance to hands folded in prayer or a three-leaf clover.

The simplicity of the ingredients — water, flour, yeast, sugar, and salt — makes *pretzels* ideal for Good Friday supper and throughout Lent.

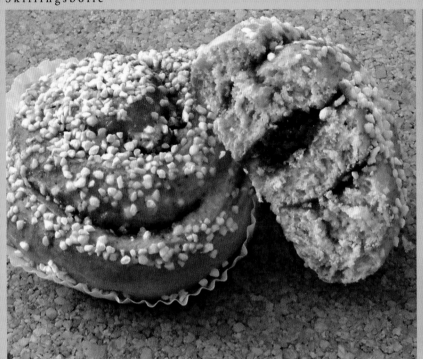

Skillingsbolle (cinnamon rolls)

The name comes from the price paid for these sweet rolls when they started to become famous in Norway: one *skilling* (shilling). Even today, the scent of freshly baked *skillingsbolle* wafts from Norwegian bakeries every morning. Delicious!

Ingredients (makes 30):
5 cups flour, 1/2 cup sugar, 7/8 cup butter (or margarine), 1/2 oz active dry yeast, 7/8 cup milk, 2 tbsp cinnamon, 3/8 cup sugar, 1 egg white

Warm the milk and dissolve the yeast in it. Put the flour, sugar and butter in a bowl. Add the milk and yeast. Knead the dough until smooth and elastic. Cover with a tea cloth and set aside for an hour. Meanwhile, blend the sugar and cinnamon. Divide the dough in half and roll each one out with a rolling pin. Sprinkle both sides with sugar and cinnamon. Lay them on top of each other roll them lengthwise into a cylinder. Cut them into half-inch slices. Line a cookie sheet with baking paper and put the slices on them, pressing slightly. Brush with egg white and sprinkle with the remaining sugar. Bake in a preheated oven at 350 °F for 15–20 minutes.

Croque monsieur
The remote origins of this enormously popular snack can be traced to a Parisian café, and even Marcel Proust talked about it in *À la recherche du temps perdu*. The reasons behind the combination of the two terms in its name — *croque* (crunch) and *monsieur* (mister) — are unclear.

Ingredients (makes 4):
8 slices of sandwich bread, 4 tbsp butter, 4 slices ham, 1 cup milk, 1/3 cup flour, 3/8 cup grated Gruyère, salt, pepper, nutmeg

There are numerous variations of the classic *croque monsieur* (just bread, ham, and Gruyère), but one of the most common is made with béchamel. To make the sauce, put the flour and half of the butter in a saucepan over low heat. Slowly whisk in the cold milk and bring it to a boil, stirring constantly to keep lumps from forming. When the béchamel is ready, add the salt, pepper, and nutmeg. Set aside. Grease the sliced bread with the remaining melted butter. Place the ham and some of the cheese on half of the slices, and place the other slices of bread on top. Cover with the béchamel and the remaining cheese. Bake in a hot oven for 10 minutes and serve.

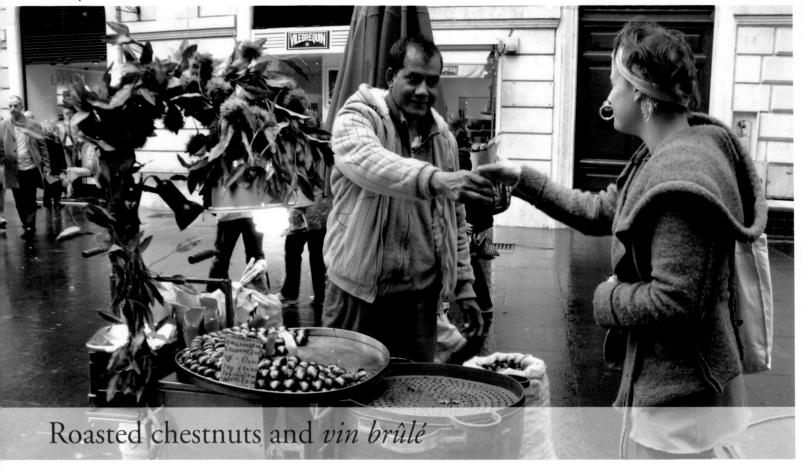

Roasted chestnuts and *vin brûlé*

When the Alps are dusted with snow, the days grow short, and the windows of wooden chalets glow with a warm light, the squares of mountain towns come alive. People hurry through the street, chased by the biting cold, but they slow down when they come to the braziers of chestnut vendors, as a delicious smell fills the square. A crescent-shaped cut carved skillfully onto each chestnut before roasting makes the scalding golden fruit easier to peel. In the houses chestnuts are roasted on top of the stove or in the fireplace, where a trivet is used to hold the characteristic long-handled pan. When chestnuts are roasted over a fire, they are better if they are stirred frequently.

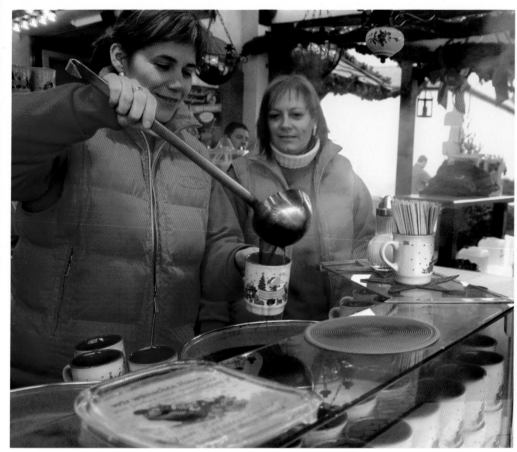
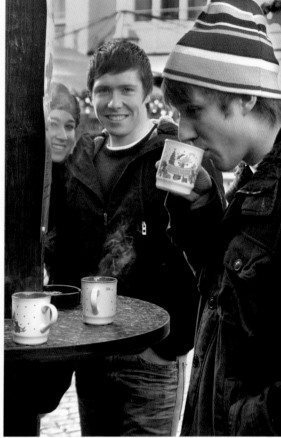

A street vendor cuts a fine figure with his orderly cart of roasted chestnuts; a steaming cup of *vin brûlé* at the Frankfurt Christmas market.

The occasion permitting, the hot chestnuts can be wrapped in a cloth sprinkled with wine to add a gourmet touch. Wine can be enjoyed in these same squares with the same atmosphere and under the very same snowcapped mountains. Try going for a stroll through the streets of Innsbruck in winter. At sundown the air becomes redolent with spices rising from huge containers of steaming *vin brûlé*, hot and bracing red wine simmered with sugar, cloves, spices, and sliced citrus fruit. It celebrates friendship when shared in a *grolla*, which is passed from hand to hand and sipped while browsing the stands at Christmas markets. *Vin brûlé* fills you, cheers you, warms you . . . and smells delicious.

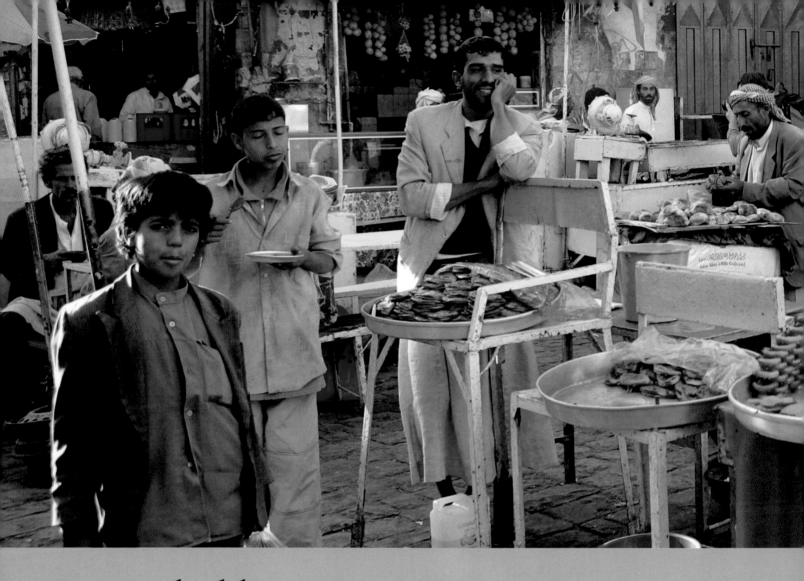

Middle East

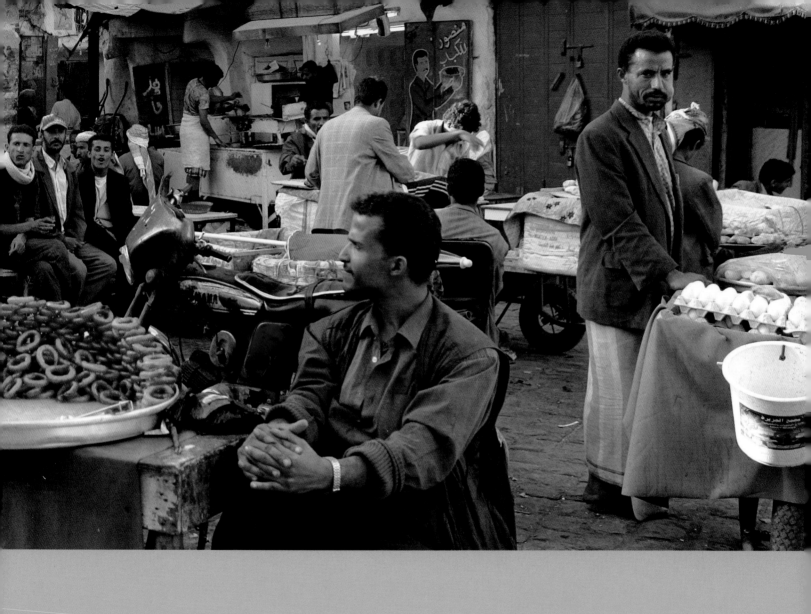

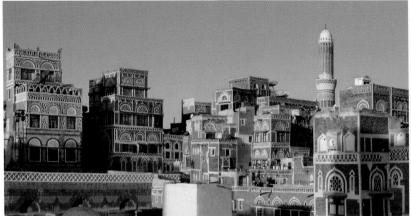

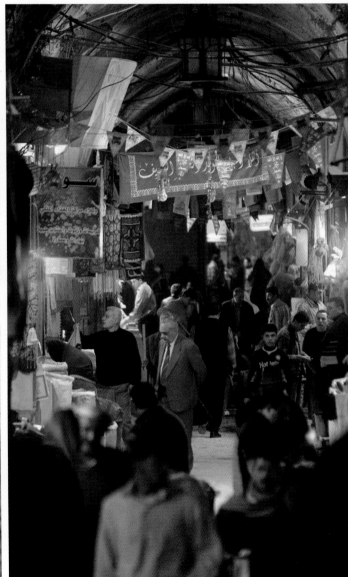

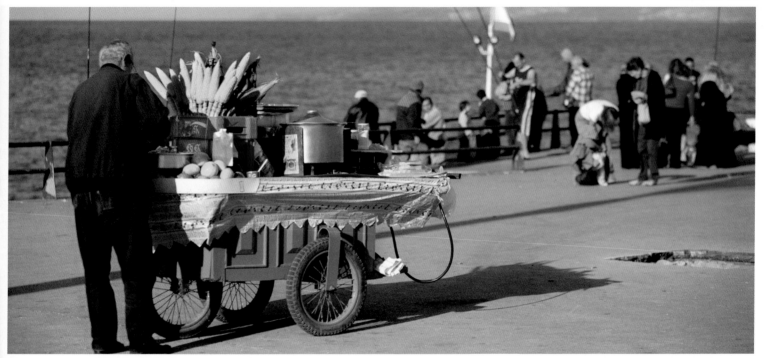

From p. 68: The salt *souq* in the old city of San'a', Yemen; the Syrian markets of Aleppo and Damascus; the Beirut Corniche, populated with corn vendors.

Exploration, caravans, ancient civilizations, incense, perfumes and spices...

This is the Middle East, a little corner of the world whose very name evokes allure, fragrances, incense, secrets whispered behind veils, elegance, traditions, discoveries, religious mysticism, and stories going back thousands of years.

The other shore of the Mediterranean seems to open the gates to an unknown universe. The capital city of Damascus is a center of great beauty and culture, the microcosm of vendors proffering tamarind and fruit juice, tiny shops chock-full of dates and pine nuts,

pistachios and almonds, raisins and rose petals. They prelude eating pleasures: the inviting ambassadors of a cuisine that is simple in taste but elaborate in preparation. The culinary tradition is the result of the varied cultural input that has reached this

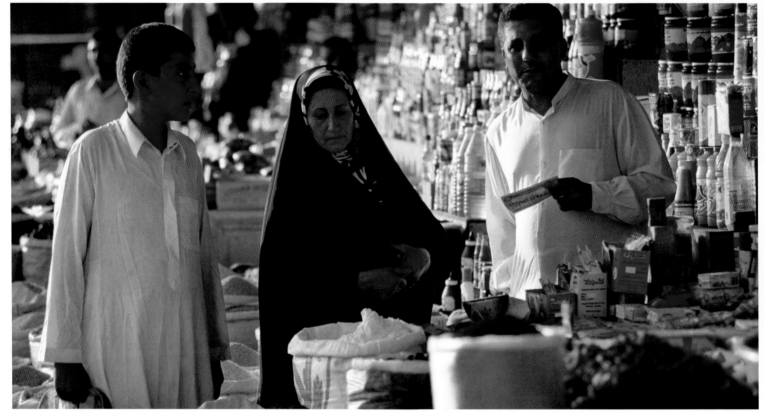

The market of Basra, an Iraqi port city close to the confluence of the Tigris and Euphrates, in the southeastern part of the country.

area, which has always been the crossroads of trade, people, and languages.

This input then drew on local eating habits, which favored the development of unique urban structures nestled around the *souqs*. The markets bustle with life. At breakfast time, men cram around the handful of tables at tiny restaurants, while young people run through the crowds with enormous trays carried over their heads, laden with dishes to bring to businesses and offices.

The *souq*, the heart of city life, comes alive late in the morning, when the light bulbs are turned on, business resumes, and the ritual of breakfast is celebrated. The culture of food is visible everywhere, permeating the Middle Eastern day, just like the love for simple ingredients, transformed into an array of dishes often interpreted based on personal taste. The morning starts with tea, bread, and a blend of herbs and spices such

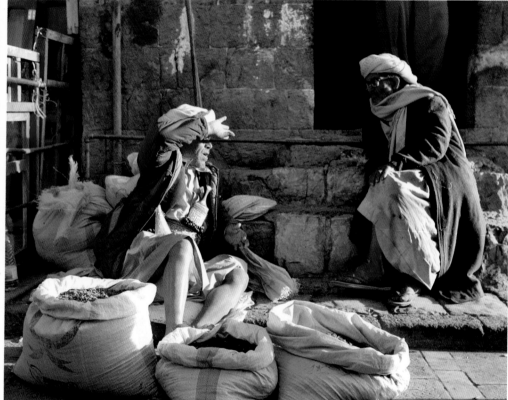

Yemenite street vendors hawking dried fruit; tasty and invigorating *fuul*, cooked in intriguing copper pots, is the most sought-after breakfast food at the Aleppo market.

as thyme, sesame, and sumac (*za'atar*), followed by an invigorating soup of fava beans (*fuul*) and olive oil. It continues with lunch, a true gastronomic spectacle with a myriad of hors d'oeuvres known as *mezze* (or *meza*). It is a triumph of dips made of legumes and vegetables, eggplant, zucchini, tomatoes, cucumbers, along with spinach, cheese, and ground meat, all of which served with flatbread made of flour and grain.

Lebanon is the leader in this, and its neighbors follow suit. After the appetizers, the main dishes tend to be far simpler: grilled or roasted meat. The meal ends with fruit or desserts drenched in honey and orange blossom water, covered with crushed pistachios or almonds, or with custard slathered between countless layers of paper-thin sheets of pastry.

Eating is a multisensory emotion, a convivial rendezvous around the table that

A cup of mint tea along the streets of a Yemenite village; freshly baked bread at the covered market of Khan el-Khalili in Cairo, Egypt; a large container for fried food at the market in Bayt al-Faqih, Yemen.

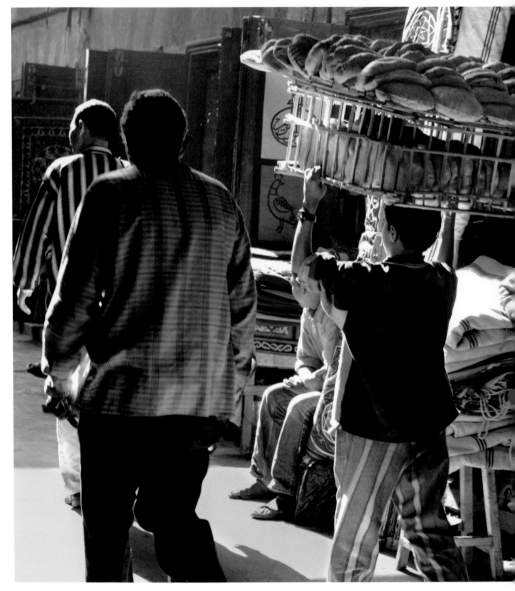

stretches out for hours. Above all, it is always about sharing and knowledge.

And this is true even in the streets, where food entices the occasional visitor, for it is a celebration that beckons participation, a delicious invitation that is impossible to resist.

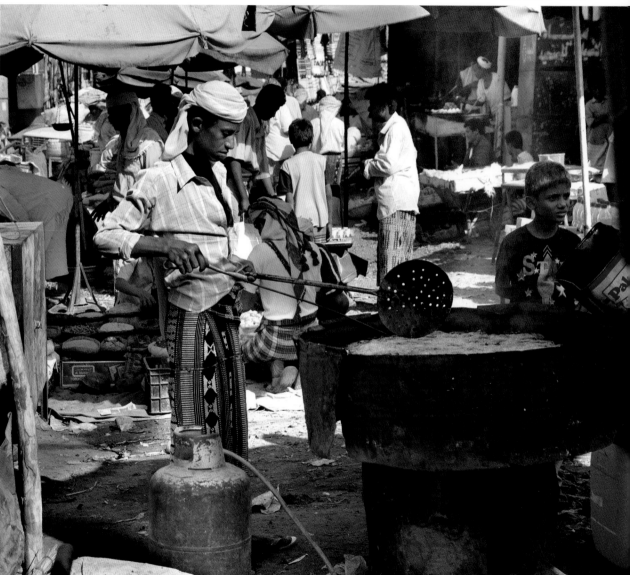

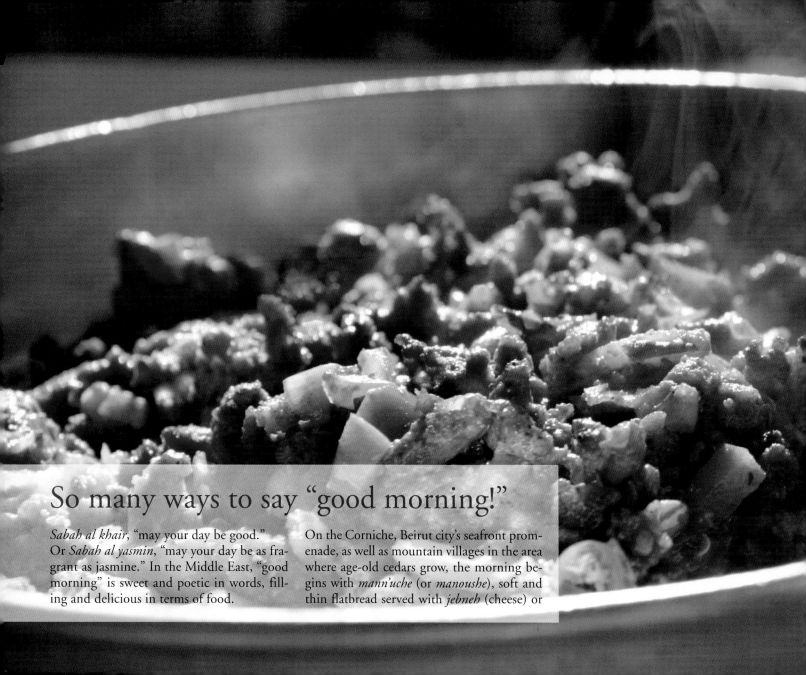

So many ways to say "good morning!"

Sabah al khair, "may your day be good."
Or *Sabah al yasmin*, "may your day be as fragrant as jasmine." In the Middle East, "good morning" is sweet and poetic in words, filling and delicious in terms of food.

On the Corniche, Beirut city's seafront promenade, as well as mountain villages in the area where age-old cedars grow, the morning begins with *mann'uche* (or *manoushe*), soft and thin flatbread served with *jebneh* (cheese) or

White coffee

It takes less than 15 minutes to prepare one of the most intriguing beverages in the land of cedars, which makes one of the region's finest orange blossom waters. This fragrant infusion is enjoyed after meals because it aids the digestion.

Ingredients (makes 1 cup):
1 cup hot water, 1 tsp orange blossom water, 1 tsp powdered sugar, citrus zest

Heat the water with the sugar. Stir and bring almost to a boil. Add the orange blossom water and citrus zest, and boil over a medium flame for 2 minutes, stirring constantly. Filter and serve immediately. The beverage should be steaming hot.

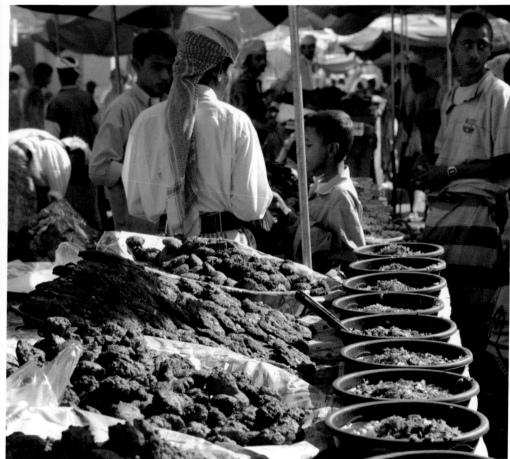

From p. 76: Grilled mutton and vegetables; Yemenite sauces and vegetable fritters; *za'atar*, a blend of herbs made with thyme, sumac, and sesame.

za'atar blended with olive oil and spread on top. It is cooked on large red-hot iron "mushrooms" called *sage* and, as soon as it's ready, it is rolled up with slices of tomato and mint, and then served in paper, rolled up halfway. Lebanon's most famous sandwich is eaten while walking around with friends. In the alleys of the *souq* of Aleppo, in northern Syria, the shops that work the most at breakfast time are those that cook and sell *fuul* outside. This soup of fava beans and tomatoes is simmered in potbellied receptacles with a nar-

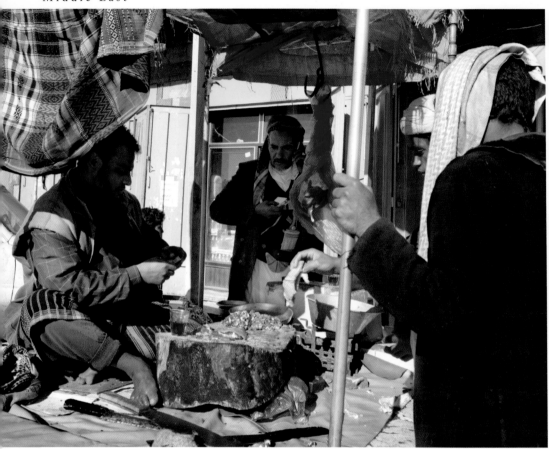
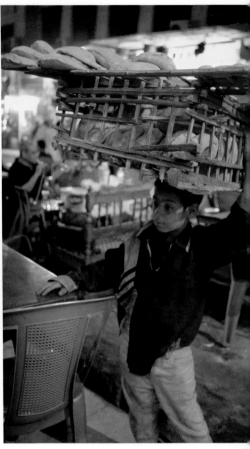

A Yemenite butcher in front of a restaurant; cake, a sweet bread sprinkled with sesame seeds, is carried in a curious container at the Egyptian market in Cairo.

row neck. Made of copper or aluminum and designed specifically for this dish, they are bent forward as if they were waiting for a ladle to scoop the steaming soup through the narrow opening. A true store of energy to get through the entire day, *fuul* is eaten with Arabic bread (*pita*).

It is served in ceramic bowls to patrons who eat standing outside the shop and in cardboard bowls to those in a hurry. Although the recipe is simple, each cook has a personal secret that, in many cases, yields true marvels. In Jordan, in the heart of old Amman, the world-famous Hashem Restaurant even serves *fuul* in the middle of the night.

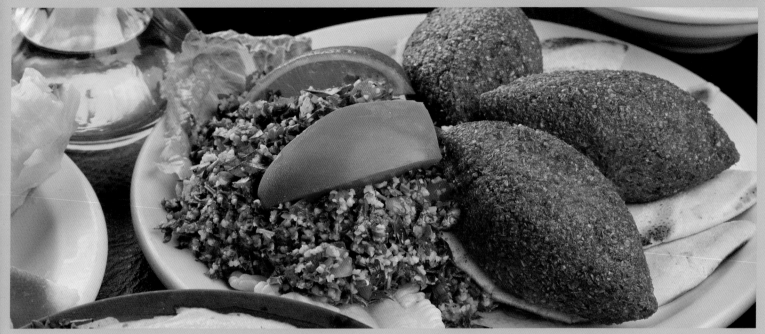

Kibbeh (meatballs)

There are many varieties of *kibbeh* (or *kubbeh*), including a "raw" type eaten as a sort of tartare. However, the most famous preparation is the one served in all typical restaurants of the Middle East with flavored yogurt. The key ingredient is *bulgur*, dry sprouted wheat that is cracked coarsely or ground for a finer texture, the latter being the best type for *kibbeh*.

Ingredients (makes 50):
For the filling: 7 oz ground lamb, 1 chopped onion, 1 cup pine nuts, cumin, pepper, olive oil
For the casing: 2 1/3 cups *bulgur*, 1 1/8 lb ground lamb, 1 onion, mint, parsley, cumin, Lebanese seven spices, cold water, frying oil

To make the filling: Toast the pine nuts in a little oil. Stir in the chopped onion, the spices, and the meat, and cook for 15 minutes. To make the casing: Rinse the *bulgur* well and soak for 2 hours. Rinse again and squeeze out any excess water. Put the meat, onion, spices, and herbs in a food processor. Add a little water and blend. Add the bulgur and blend again. Mix well. Scoop a spoonful of the mixture at a time and, using the palm of your hand, mold it into a cup shape and place a teaspoon of the filling in the middle. Close the croquette around the filling and pat it into an egg shape. Fry in plenty of oil.

The welcome coffee of the Bedouins

Coffee, without any sugar and with cardamom, is served three times in tiny cups without handles, and is drunk steaming hot. Arabic coffee is not merely a beverage, but a symbol of welcome. Contracts are stipulated and marriages arranged over a cup of coffee; friendships begin with one and turning it down can mean the end of even the most enduring relationship. The heart of Jordan is red, like the sands of the desert of Wadi Rum, the "stage" where the Bedouin tribes reprise the spectacle of their culture, composed of few words and simple gestures. An open black tent and a coffeepot ever ready on the embers burning on the sand mean that every guest will be welcomed in grand style and can stay as long as he likes. The monument of a coffeepot at the entrance to the villages welcomes wayfarers, who are received with coffee. One cup to welcome them, the others to seal the friendship and the commitment to defend the new brother. Accepting a cup of coffee is a way of rendering honor.

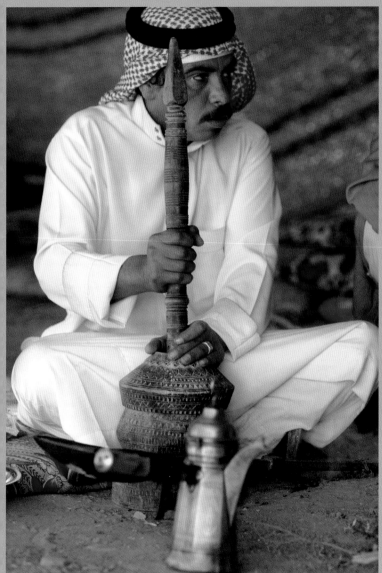

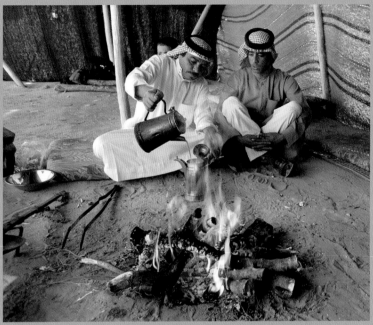

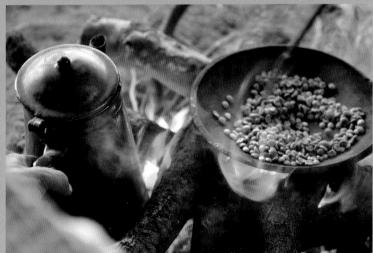

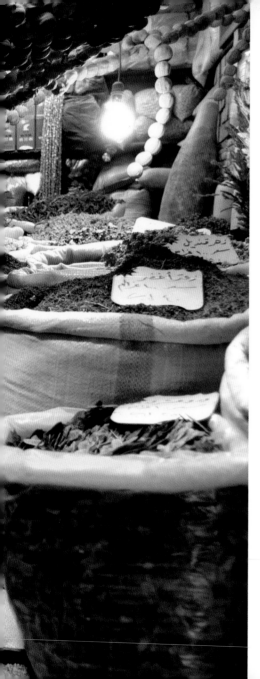

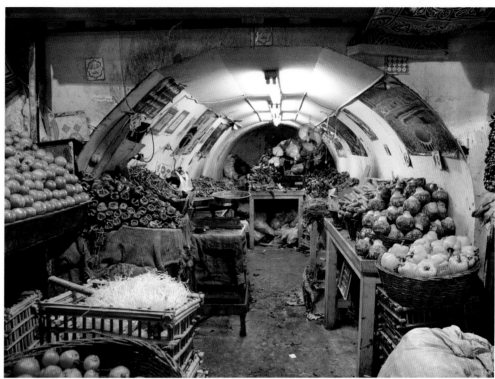

The astonishing array offered by the traditional Syrian *souq*: fresh vegetables, dried fruit and nuts, jars and bulk products.

Flatbread, meat, and vegetables: the Syrian tradition

It seems that Aleppo is the capital of Syrian culinary excellence. Its inhabitants think so, and it is also confirmed by the presence of the Culinary Institute proudly opened in this ancient city that was a crossroads for caravans, and thus has long been a point of encounter and exchange of cultures, religions, and habits. The alleys of Aleppo's *souq*, a welter of narrow alleys with which only the locals are truly familiar, are a popular preview of just how important food is here.

Aleppo: ground meat used to stuff buns baked in the oven; a colorful fruit stand at the market in Alexandria, Egypt

The fame of Syrian villages and cities is tied above all to meat and vegetables. The former are wrapped in a delicious *shawarma* (in Damascus, the ones made in the Christian quarter are famous); the latter are transformed into fillings for pastry rolls called *burak*. Steaming behind the windows of bakeries, they are as delicious to eat as they are elaborate to make. The dough must be rolled out a number of times into paper-thin lay-

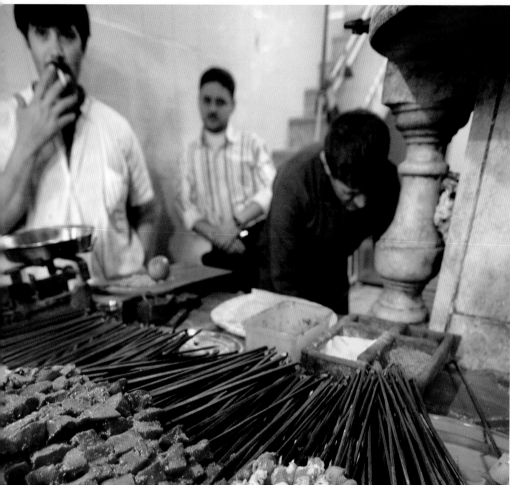

Mutton skewers are served with flatbread; ground meat is used as a filling for various plates; sautéed pluck is a popular dish.

ers set on top of each other. It is then filled with spinach or cheese, and baked or fried. *Kibbeh* are also made of meat and are equally elaborate. These fried egg-shaped croquettes are prepared with sprouted wheat (*bulgur*) that is filled with ground lamb. Another type of street food is *lahm b-ajin*, flatbread baked in a stone oven and covered with lamb prepared with onions, a seven-spice blend, pine nuts, and pomegranate juice.

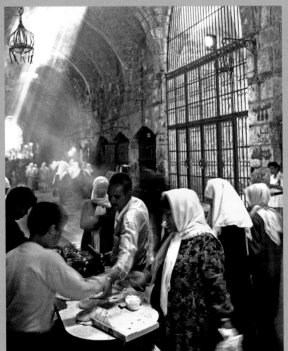
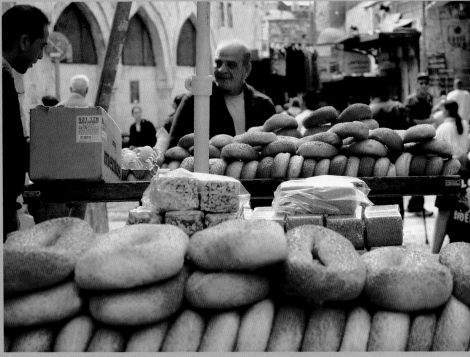

Mahane Yehuda and the Damascus Gate, Jerusalem, Israel

If there is a place where the meaning of food goes beyond pure gastronomic value to become rooted in tradition, culture, and religion, it's Jerusalem. The heart of the old city, divided into Muslim, Jewish, Armenian, and Christian quarters, is not only the treasure of common religious heritages, but also of culinary delights. Thus, at small restaurants and market stalls you find common ingredients and food, purchased and enjoyed by people of all faiths. The Damascus Gate greets all those who enter with an extravaganza of fruit displayed in wicker baskets or on huge steel platters, while wooden carts sell loaves of semisweet bread or cakes. Outside the walls, in the western part of the city, fruit, bread, and spices are spread out at the stalls in the enormously popular market of Mahane Yehuda, the haunt of observant Jews, as it offers products that are guaranteed to be kosher, meaning that they are permitted by Jewish dietary laws. The most cross-cutting dish? Classic lentil soup, served with a squeeze of lemon, which is also sold at street corners.

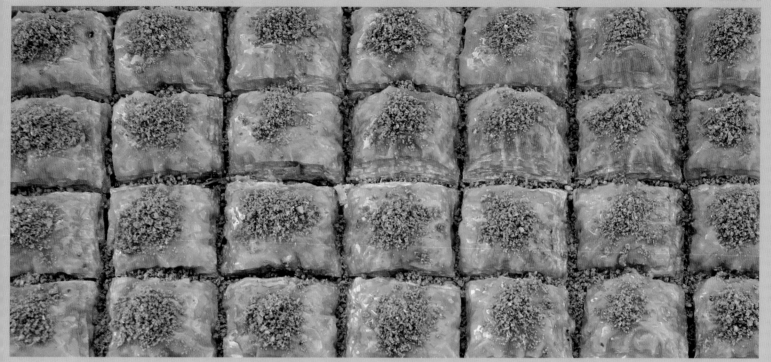

Baklava

The origins of this dessert, now made in many countries in the Middle East and around the Mediterranean, have yet to be clarified. According to some scholars, the first recipe for *baklava* (similar to the modern one) dates to the 14th century, but another theory sustains that as far back as the Assyrians — eight centuries before Christ — people would eat thin sheets of pastry sprinkled with honey and nuts, thus crediting them with the invention.

Ingredients (serves 6):
1 lb phyllo dough, 3 cups chopped almonds, 1 1/3 cups chopped pistachios, 3/4 cup butter (melted). For the syrup: 2 2/3 tbsp honey, 2 1/3 cup sugar, 1 1/3 cup water (flavored with orange blossom water if desired), 1 tbsp lemon juice

For the syrup: Dissolve the sugar in the water with the honey and lemon juice. Cool and then refrigerate. Butter a rectangular baking pan. Place a sheet of phyllo dough on the bottom and brush with the melted butter. Repeat with 5 more sheets of phyllo dough. Sprinkle the layer of 6 sheets of phyllo dough with the chopped almonds and pistachios. Cover the nuts with 6 more sheets of phyllo dough, brushing each sheet with the melted butter. Using a sharp knife, cut into diamond shapes. Bake in a preheated oven for 40 minutes at 355° F. Remove from the oven and immediately pour the syrup over the top, making sure that it penetrates to the bottom. Cool and serve.

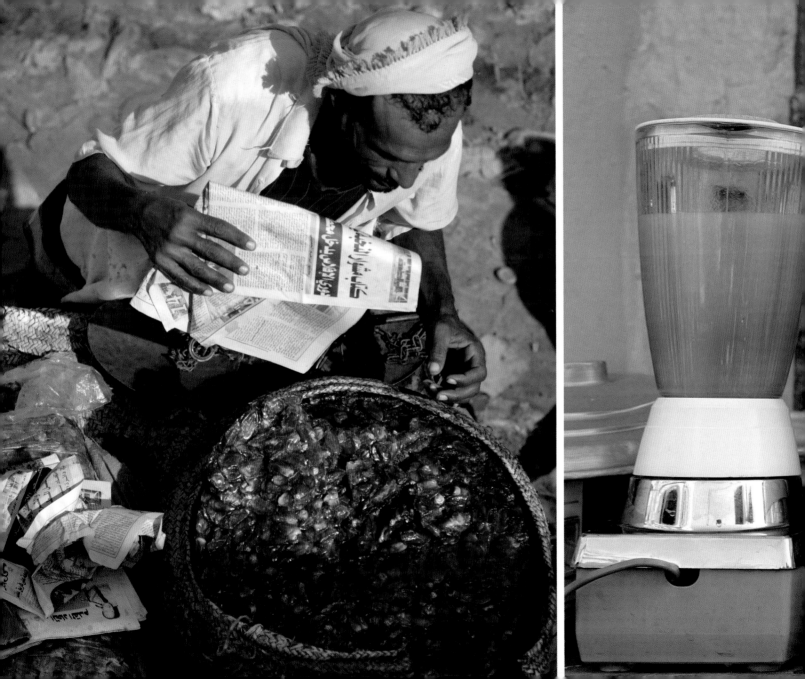

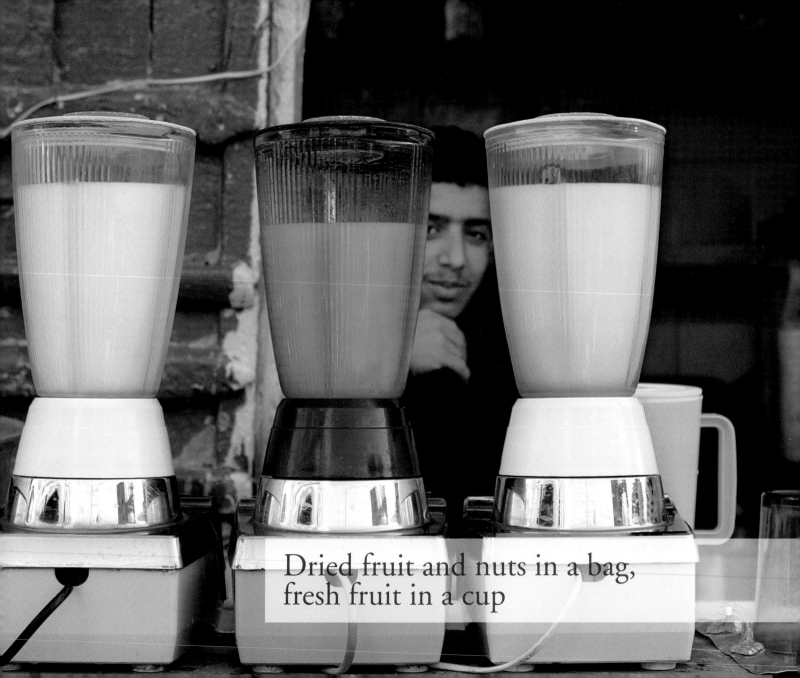

Dried fruit and nuts in a bag,
fresh fruit in a cup

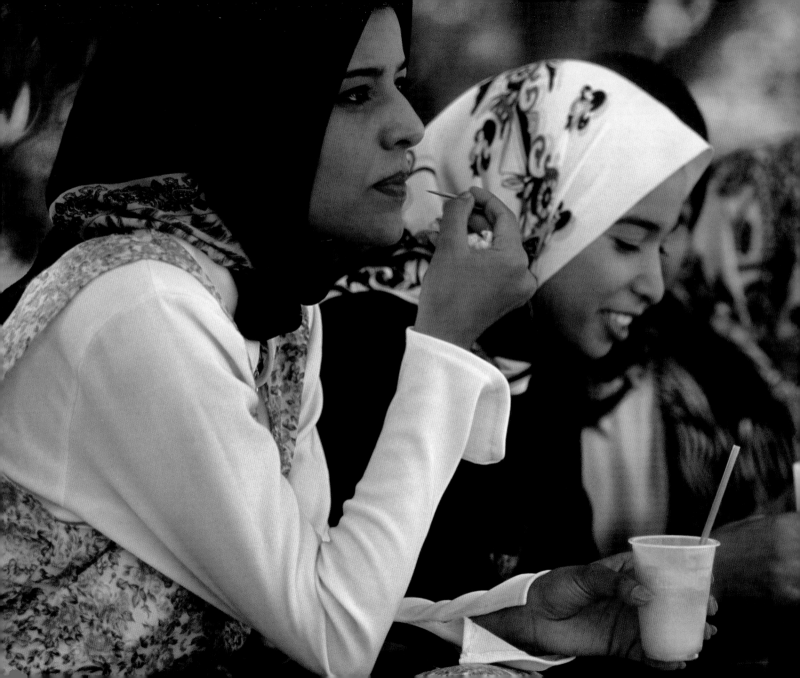

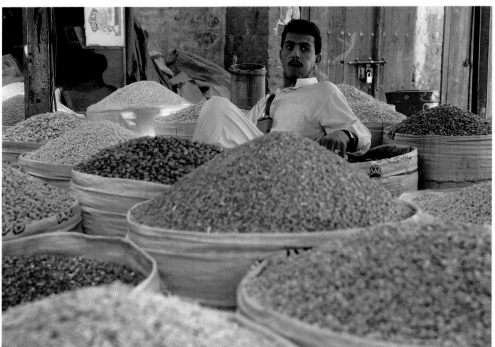

From p. 90: Fresh shakes are a favorite throughout the Near East; dried fruit and flower petals in San'a', Yemen.

Aleppo pistachios, Iranian pine nuts and raisins, Turkish almonds, dates from Palmyra: the only way to travel around the Middle East is by examining the bags in the shops of dried-fruit vendors.

At the market in Sana'a, framed by the white lace that makes the Yemenite capital so unique, tiny spaces become the showcase of delights that, dried and odorless, suddenly reveal their full and intense flavor as soon as you bite into them.

Whole or minced, crushed or shaved, pine nuts, pistachios, and almonds couldn't be more inviting, and they promise to work miracles as ingredients or decorations for rich pastries covered in honey and sugar syrup. The vendors sitting behind their bags overflowing with dried fruit and nuts seem lost in thought. But try asking them about the provenance of their raisins or the price of their walnuts — everything is written strictly in Arabic! — and their faces light up, and

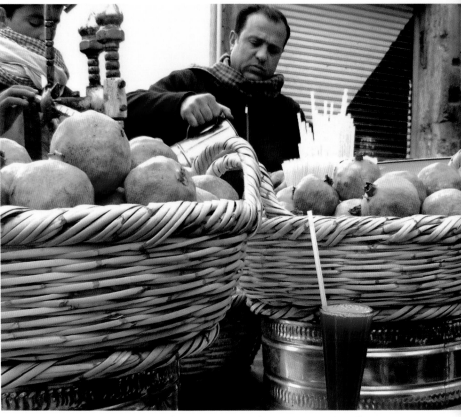

Green lemons and pomegranates ready to be blended on the carts of street vendors; a Yemenite vendor offers passersby dates from the entire Middle East.

with a smile they'll ask you to sit down to taste and compare their products. And then you're off again, purchase in hand, munching these delights along the way.

At street corners you'll find carts with fresh fruit, squeezed on the spot: oranges, pomegranates, mulberries.

It's all seasonal fruit, but for a few coins you'll continue on your way with a glass brimming with juice.

Then you hear a clanking noise and turn around to find a vendor dressed in an embroidered vest, white shirt, and loose trousers. Donning a fez on his head and a curious

chased copper container on his back, he wanders the streets, attracting the attention of passersby with the music of his rattling steel cups. This familiar sound heralds the arrival of the tamarind vendor, a spectacle of yore offering a taste of juice poured into a cup with the deft movement of his back and shoulders.

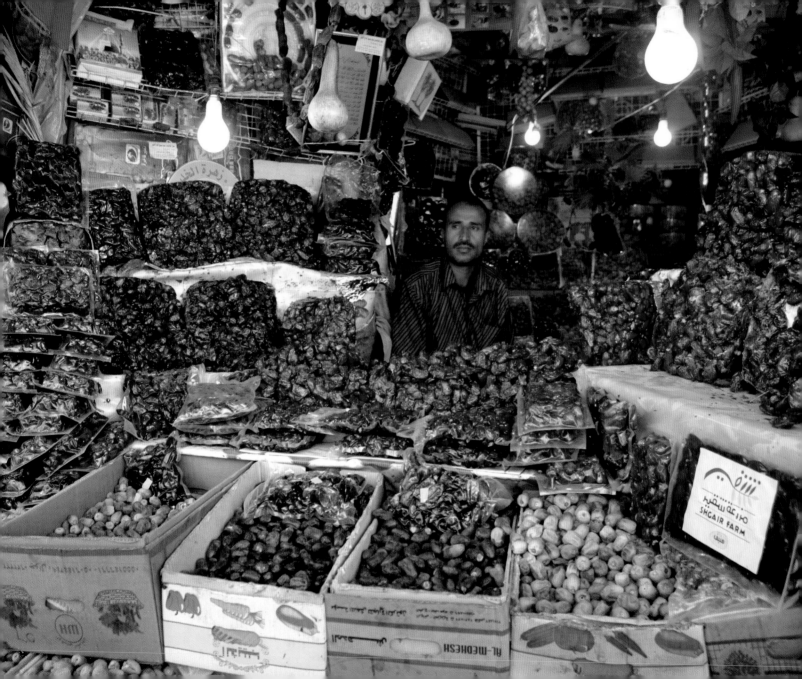

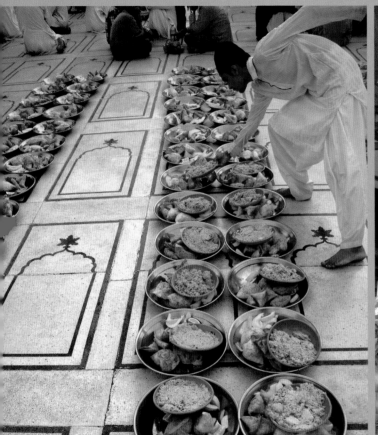

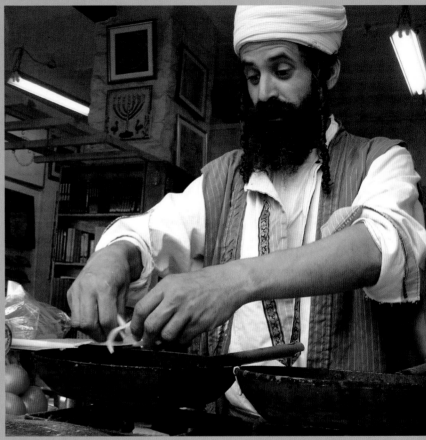

Iftar and Shabbat

When the evening star appears in the sky, the muezzin's voice floats over the rooftops. It is the start of the *iftar*, the meal that breaks the Ramadan fast. Families gather around the table, and in the street people line up at bakeries to enjoy delights such as *qutayef* filled with dried fruit, nuts, and cheese, and folded over into a crescent.

The *Shabbat* bread served at the beginning of every Friday supper in Jewish homes is also a ritual. The two loaves of braided bread must be covered during the *kiddush* until they have been blessed. This is shared food that must be prepared by 7 p.m., when all activities cease, because body and soul must be devoted exclusively to God.

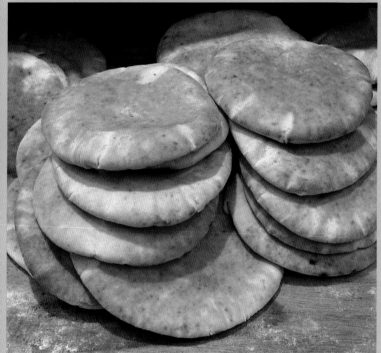

Arabic bread

Ingredients (makes 10):
6 cups all-purpose flour, 1 1/4 cup lukewarm water, 0.9 oz fresh active yeast, 1 1/4 tsp sugar, 2 tsp salt

Flour, water, yeast, and a dash of salt: the ingredients for Arabic bread (called *pita* in some areas) are extremely simple. The dough is split up into disks that swell in the oven to form the typical "pocket" that can be filled with meat or vegetables, to be eaten on the street. The secret to keeping it soft? Put it in plastic bags as soon as it comes out of the oven to seal in the moisture.

Challah

Ingredients (makes 1 loaf):
2 1/2 cups flour, 0.9 oz fresh active yeast, 1 egg, 1/4 cup sugar, 1 1/3 tbsp oil, salt

Challah is the Jewish bread served at the *Shabbat* supper, where it is set on an embroidered cloth before being shared. The braided loaf is sweetish and dense. *Challah* is made with flour, sugar, eggs, oil, butter, water, and yeast. It is raised twice, before being split up into smaller portions and then after braiding. Before baking it is brushed with egg to give it a golden sheen.

Far East

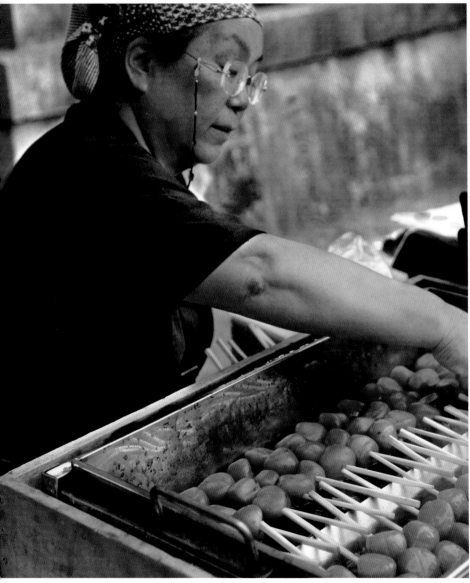

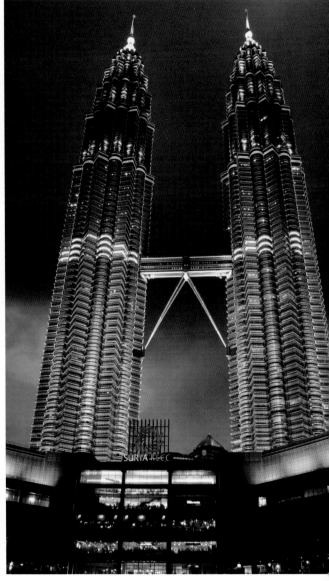

From p. 98: Market in Myanmar; rice-flour skewers at the Tenjin-San market in Kyoto, Japan; the Petronas Towers in Kuala Lumpur; Malaysia's biggest city is constantly on the go.

Beyond the Urals and the oceans, the mysterious and fascinating culture of the Far East opens its doors to us.

If we wanted to choose just one place to symbolize the Far East, it would have to be Malaysia. In fact, this idea has even been adopted as a promotional campaign: *Malaysia truly Asia*, the quintessence of Asia. This is not only because, over time, many of the streets of its cities have

gradually acquired the appearance of the nearby towns left behind by those who have flocked here to trade their wares and live, but also because — thanks precisely to this to-and-fro — all of its transit points, landing places, and fusions of cultures have been reinterpreted into

food: a blend of styles, syncretism of worlds, balance of tastes. There is room for everyone in this big little Asia, but to grasp the nuances of this continent we must travel to its far eastern reaches and Japan. Everything seems different here, even the very concepts of time and space, and food is

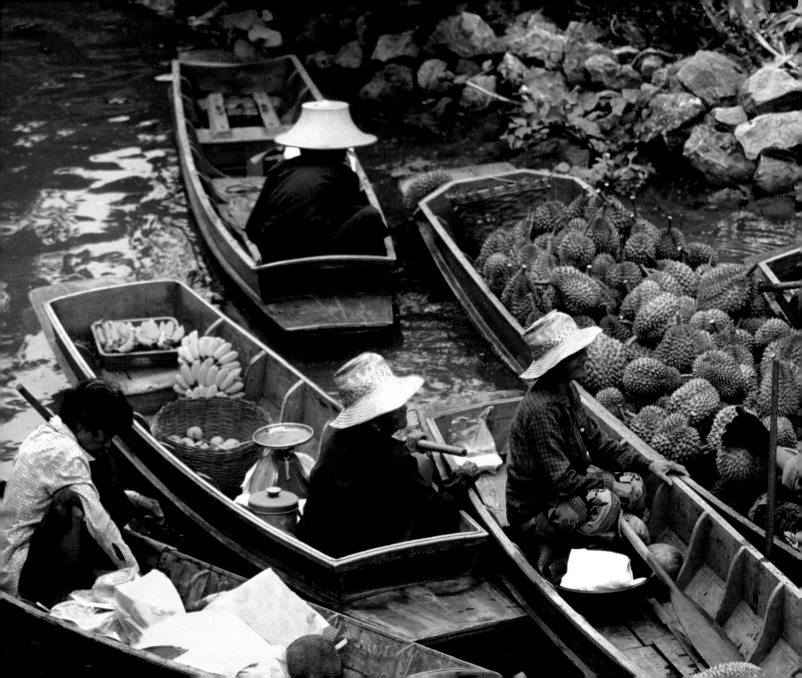

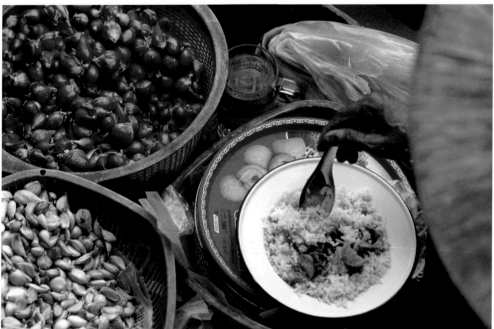

The floating market in Bangkok, Thailand, which offers fruit, vegetables, and foods.

culture, care, passion, practice, and the balance between oneself and the world. It is ritualistic in its preparation and mysterious in its ingredients, the expression of philosophy and art, but above all it represents a wealth of unexpected and unfamiliar offerings.

If there is a place that diverges from the essence of the Far East, that is unique and distinct from the rest of the continent, it's Japan. Made of up countless recipes have that been overshadowed by the worldwide fame of sushi and sashimi, which in Japan are merely two of many dishes, the cuisine of this island country is expressed in thousands of ways, often in the streets and at bar counters where sushi is sold for a few yen to be eaten while standing. It approaches the absurd and transforms the act of eating into a gesture imbued with meaning. For the same reason, Japan transforms a cup of tea into an infinite ritual.

Malaysia and Japan, two extremes of the same world, are at opposite poles because of their differences but are united by their affiliation, the common but singular ground that has generated thousand-year-old cultures and arcane traditions.

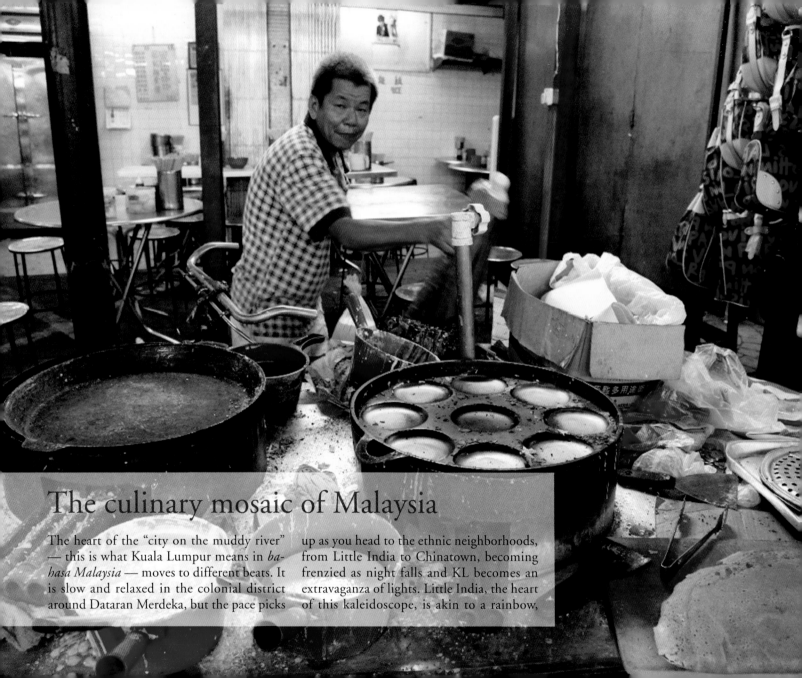

The culinary mosaic of Malaysia

The heart of the "city on the muddy river" — this is what Kuala Lumpur means in *bahasa Malaysia* — moves to different beats. It is slow and relaxed in the colonial district around Dataran Merdeka, but the pace picks up as you head to the ethnic neighborhoods, from Little India to Chinatown, becoming frenzied as night falls and KL becomes an extravaganza of lights. Little India, the heart of this kaleidoscope, is akin to a rainbow,

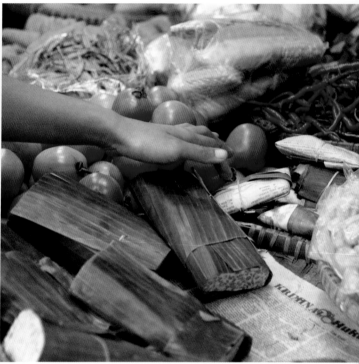

The streets of Kuala Lumpur are an extravaganza of uncooked or cooked food, which can be tasted in small containers or wrapped in banana leaves.

with multicolored saris hanging outside the myriad of small shops. It offers irresistible bazaars, full of temptation in the form of perfumes, spices and incense, bracelets, rings, facial and hand decorations, and figurines of deities with animal forms. Next to them, stands lined up on the sidewalks fry the spiciest vegetables and sweet *parota* (Indian bread), feather-light pastry covered in honey and sugar. Further ahead, market stands laden with fruit take up the pastel colors of the colonial homes: pink, green, and yellow.

Malaysian cuisine is the epitome of fusion, drawing on the gastronomic traditions of all of Asia as well as Arabic influences that have arrived through trade routes. There is nothing easier than eating in the streets.

At every hour of the day and night, ubiquitous carts sell skewers of fresh fruit, meat, and vegetables. But there is also a way of eating that is exclusive to the tiny restaurants of Little India, which serve food on fresh banana leaves, as done in southern India.

The huge leaves are used as disposable dishes that are set before diners with little mounds of rice, masala, and sauces that you then mix using your hands.

Throughout the city old colonial buildings have been transformed into shophouses with

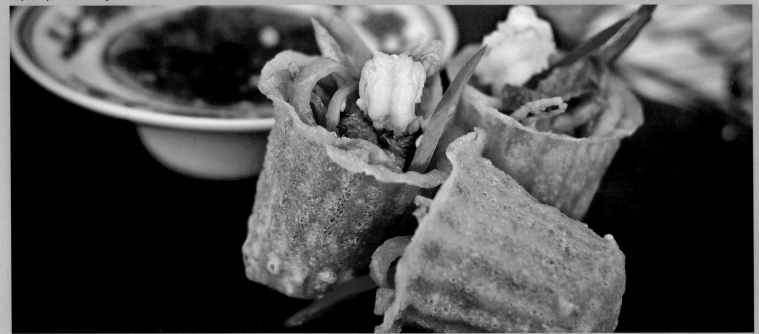

Nyonya kuih pie tee
Nyonya cuisine hails from the peninsula of Melaka, where the first Chinese communities arrived. A synthesis of Chinese and Malaysian influences, this cuisine is nothing short of a ritual. In fact, *nyonya* houses open out onto the street: All you need to do is climb a few steps to enter a small courtyard. There, behind a little altar on which candles and incense burn, you'll find women standing in front of a coal stove that is always lit, preparing something to eat, and inviting you to sit down and wait.

Ingredients (makes 40):
For the "top hats": 1 1/4 cup pastry flour, 3 tbsp rice flour, 1 egg, 2/3 cup water, frying oil, salt. For the filling: 1 lb jicama, 1/2 carrot, 5 green beans, 1 3/4 oz shrimp, 2 garlic cloves, 1/3 cup water, 1 omelet, 1 shallot, 1 chili pepper, sugar, chicken bouillon crystals, 1 tbsp oil, salt

Blend the flours, the beaten egg, a pinch of salt, and the water. Set the batter aside. Heat the oil and dip the *pie tee* mold into it. The batter should coat the sides and the bottom of the mold. Remove any excess batter and put the mold in the oil again. Separate the mold from the batter and deep-fry the "top hat." When done, remove, blot with paper towels, and place in a container.
For the filling: Sauté the crushed garlic and add the shrimp. Add the diced vegetables, a pinch of bouillon crystals, sugar, salt, and water. Cook the mixture and use it to fill the "top hats". Garnish with pieces of omelet, and the chopped shallots and chili pepper.

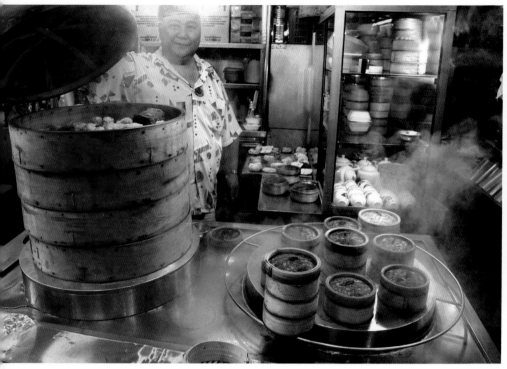 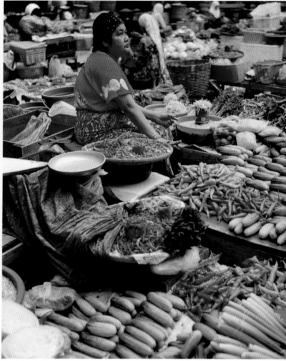

Steamed dumplings in the typical bamboo containers of various sizes; the market offers an incredible variety of fresh vegetables.

several floors. At the corners of herb and grain emporia, and close to restaurants and cafés, tiny five-foot stalls sell street food cooked in precisely that amount of space granted by the government, hence the name. Petaling Street, in Chinatown, is instead famous for its teahouses.

Boiling water is carefully poured over the dried leaves in a cup. Then the brewed tea is poured into a pitcher, the outside of which is intentionally bathed with hot water. Arms seem to dance as the tiny bowls are filled with Chinese tea.

The Malaysians instead drink BOH, which stands for "Best of the Highlands," as it comes from the Cameron Highlands, and is available at the capital's old food market.

In the evening, the quarters famous for outdoor specialties are overrun with patrons seeking the best skewers. But that's not all.

Asian Heritage Row, with its historic buildings that have become fashionable haunts, attracts those who love the nightlife.

Here you can find street food at all hours of day and night, and the district has become the quintessence of Kuala Lumpur.

On the street you can also eat as you sit in an armchair and relax with a foot massage, a must here, as you gaze at the skyline with the splendid Petronas Towers in the background.

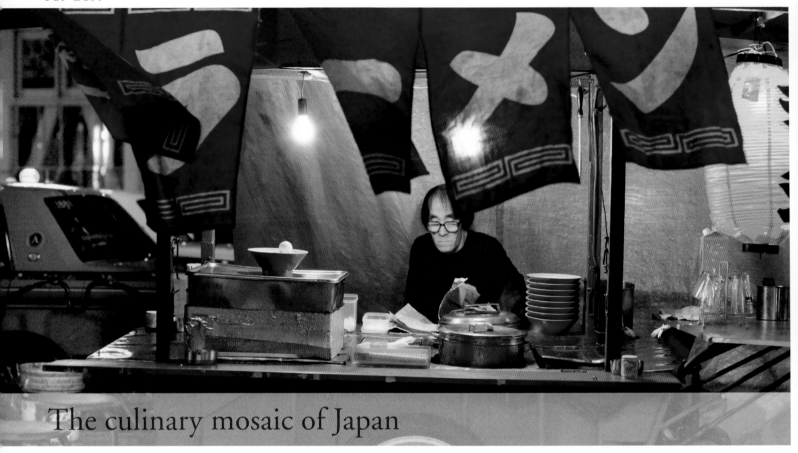

The culinary mosaic of Japan

Discussing sushi with the Japanese? You can only do it in Tokyo, where you'll find the very best and freshest, made near the fish market and served in the streets, and at restaurants and sushi bars. It seems that time really is money around here, and the food stands to be tried at once are proof. Businessmen on their way home from work line up at eateries that serve carryout *ramen* (Japanese noodle soup) or head to a pub, their inseparable briefcase in hand, for a bowl of this new Japanese fast food. Along with the noodles and broth, these bowls hold an abundance of ingredients that vary to cater to different tastes: pork, seaweed, eggs, and bean sprouts. A sign on the door tells you which eateries specialize in these dishes, and then all you need to do is walk through the strips of fabric that line the entrances to Japanese restaurants... and enjoy!

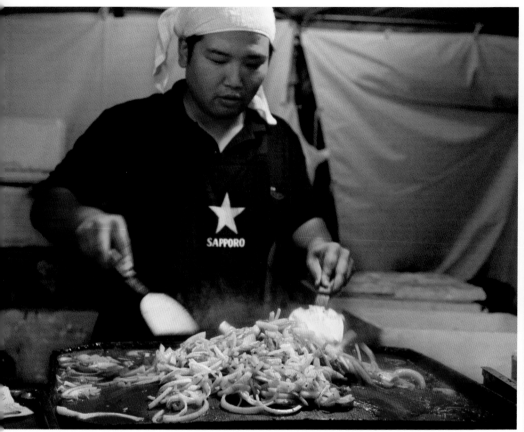

Tokyo, typical outdoor restaurant; the preparation of *okonomiyaki*, the quintessential Japanese pancake, requires skill and experience; the Tokyo Fish market is the temple of tuna.

The culinary mosaic of the streets of Japan continues in Osaka, the capital of fine dining in the land of the Rising Sun, followed by Hiroshima, famous for its oysters and *okonomiyaki*, a "Japanese pancake" made by cooking batter on a hot grill along with vegetables, meat, and eggs.

Around the grill, patrons wait to be served their portions, which they eat together in a very friendly atmosphere. An alley running amidst the buildings and shopping centers of Kyoto, between the new city and the old quarters with their wooden houses on the other side of the

Kamo River, holds the Nishiki Food Market. In the city of geishas, this exceptionally orderly *plein-air* food emporium is an adventure of unknown foods, accompanied by picturesque posters that are equally mysterious. In the center of Kyoto, sitting barefooted and cross-legged on

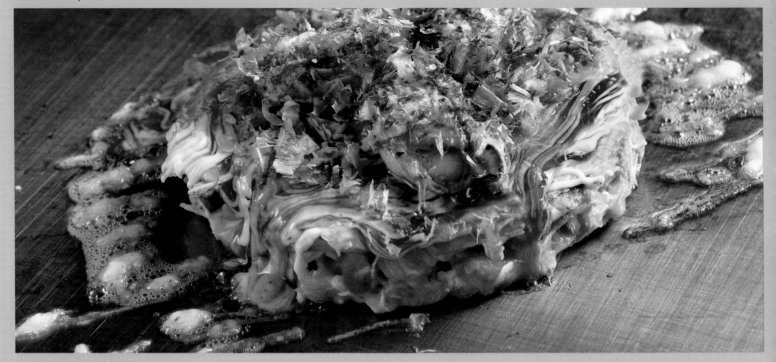

Okonomiyaki
The name of this "Japanese pancake" typical of Osaka may sound a bit strange, but its meaning is even odder: add whatever you like. And then cook it too, because one of the characteristics of this intriguing Japanese dish is that it is cooked on a grill, and flipped over again and again until it's done. Eggs, flour, and cabbage are the basic ingredients for this recipe, to which you can add your favorite ingredients (bacon, carrots, dried fish, squid, seaweed, onions, and more).

Ingredients (serves 4):
1 Japanese or savoy cabbage, 5–6 slices fresh bacon, 1 1/4 cup flour, 5 eggs, 2–3 cups lukewarm water, 1/2 packet bouillon crystals, *beni shoga* (pickled red ginger), *aonori* (as an alternative, trimmed *nori*, i.e., Japanese seaweed), *katsuobushi* (dried tuna flakes), mayonnaise, *okonomiyaki* sauce, oil

Wash the cabbage leaves and squeeze out the excess water. Remove any tough leaves and then julienne the cabbage. Put it in a bowl with the diced *beni shoga*. Flatten the bacon with a meat mallet. Beat the eggs with the flour. Dissolve the bouillon crystals in the water and add to the egg mixture. Pour the batter over the cabbage and mix. Grease a skillet with oil, and cook the cabbage and egg mixture with the bacon. Place the "pancake" on a plate and spread some mayonnaise on it. Season with the *okonomiyaki* sauce, a sprinkling of *aonori*, and some *katsuobushi*.

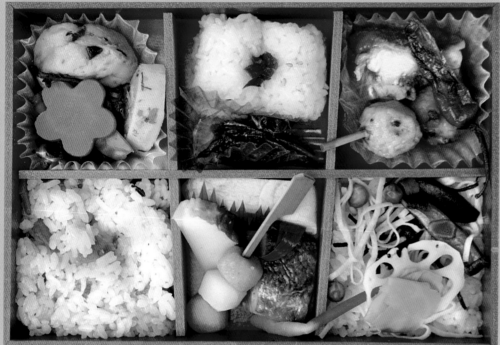

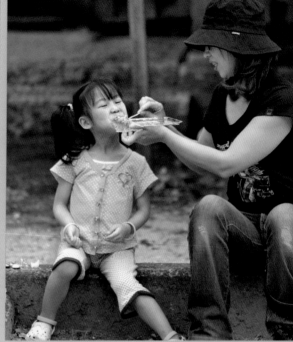

Bento

No trip to Japan would be complete without encountering a *bento*. It is a meal in a box with as many dividers as the different foods it contains. That's because this famous Japanese box is actually a sort of picnic basket. Or tray. Or multi-plate. In short, it's a carryout container that is ubiquitous in offices and schools, but it is also used for outdoor meals and picnics under the cherry trees. It dates back to the 13th century when cooked and dried rice had to be transported on long journeys from one city to another. By convention, each little compartment has a specific identity, the portions must be small, and there must be harmonious uniformity among them.

Fish or meat, pickled or cooked vegetables, accompanied by white rice, tofu, and green tea are part of the traditional *bento* menu, but the inventiveness of Japanese cuisine often comes into play. Small portions of food create compositions that can be multicolored or in nuances of one basic shade.

Extremely popular at train stations and supermarkets, they can also be found at restaurants and the stands of street vendors. Above all, however, it is at *bento* shops that you find the food arranged in themed compositions.

As you sit on a street bench, it's impossible not to glance at your neighbor's *bento*, because its appearance is at least as important as its taste.

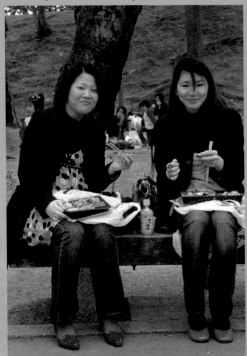
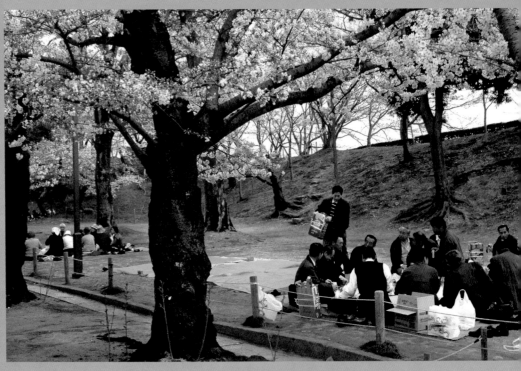

Cherry trees and picnics

Springtime in Japan. Every morning signs posted in hotel lobbies show 1, 2 or 3 petals to indicate how far along the cherry-blossom season is. The pink wave of the *sakura* is unstoppable, crossing the country day by day and creating an extraordinary atmosphere.
It starts in the last week of March on the island of Kyushu, and then slowly moves to the northeast, where it ends a month later. The commotion starts early in the morning outside the city as well. Fathers go to parks to find the most beautiful cherry tree and mark the lawn under it with a large blue cloth. The rest of the family arrives later with food and drinks, bicycles and cameras, and music and games for children. Everyone kneels in a circle and the celebration begins. Sticky rice snacks appear on vendors' carts to accompany young couples taking a walk and exchanging promises of love as they touch the blossoming branches.
But the true star of the meal at the foot of the blossoming cherry trees is the *bento*, the wooden container with compartments holding all the courses of this springtime meal.

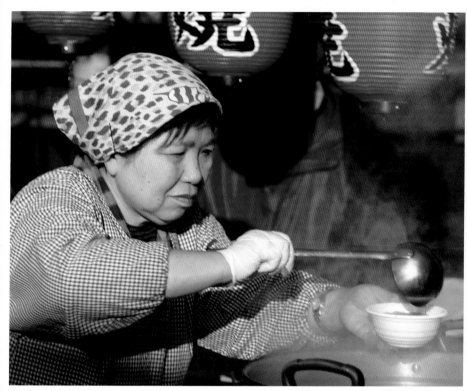
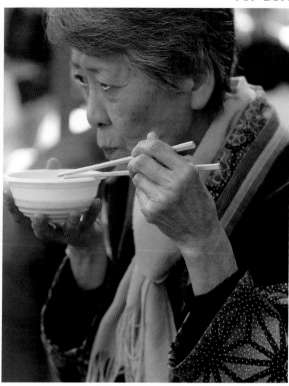

At dawn at the farmer's market of Ohara, just outside Kyoto, people consume enormous quantities of miso soup to battle the cold.

tatamis, you can taste excellent tempura and gaze in awe at the sight of extraordinarily skilled chefs preparing *teppanyaki*. Armed with razor-sharp knives, they display their artistry as they slice shrimp and Kobe beef filets, mushrooms, eggplant, and zucchini, tossing them in the air and onto on a sizzling grill at the diners' tables. If you're in the mood to discover Japanese cuisine, then *shabu-shabu* is a must. The onomatopoeic name of this dish comes from the sound of thinly sliced meat being plunged into boiling broth and then rapidly swished back and forth to cook it.

Regardless of whether we're talking about street food or a restaurant meal, Japanese etiquette is very strict about eating. Before starting, you say *Itadakimasu* to thank the animals and plants that allow us to eat in order to live. When the meal is done, you thank the gods, nature, and the cook with the words *Gochisosama deshita*. And at the table?

No shoes can be worn at restaurants and there are no chairs. You eat on your knees and do not sit cross-legged. There are also rules for chopsticks, which must never be used to dig into your bowl of rice, because food should be picked at daintily and eaten in small bites.

Indonesia's "five feet"

Yogyakarta, Indonesia: snack in a city street, next to the typical five-foot cart; batter-fried vegetables.

The curious name of the small carts crowding the streets of Indonesia means "five feet". We're talking about food carts, which the locals call *kaki lima* because they have five feet: actually, two wheels, a wooden support, and a man's two legs. That's right, because around here it's the men who do most of the cooking, and they're the ones busy tinkering with this small portable kitchen. In Jakarta, food vendors constantly move about from one neighborhood to another, stopping at the most crowded street corners, perhaps near a mosque after prayer time or at the busiest inter-sections when the sun goes down and everyone rushes home. Nevertheless, a few *kaki lima* decide to stop, and plastic stools and rickety tables instantly materialize in front of them. The most famous carts have become the destination of what are nothing short of culinary pilgrimages.

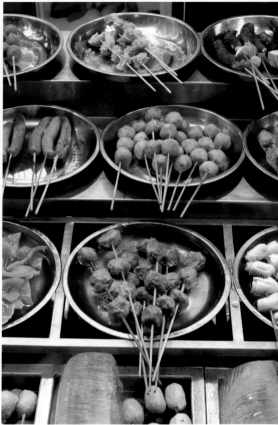

Desserts to enjoy while out and about, made with sugar syrup and colored chestnut cubes; stall with numerous versions of *satay*.

Here food is the true star at all hours, because the Indonesians eat constantly, without looking at the clock. The burners hold an inviting variety of dishes, from popular *bakso*, a vegetable soup with little meatballs, to the famous *satay* (or *satè*), which has spread from Indonesia across Asia.

These delicious grilled skewers are made of chicken or beef, but sometimes also bats and dog meat. No pork! In observance of Islam, the consumption of pork is unknown here. Food vendors sauté vegetables in woks and prepare delicious bowls of *nasi goreng*, fried rice tossed with vegetables, meat,

shrimp, pieces of fish, and spices: complete, nourishing, and popular. What better reason to make it the national dish? That's what President Sukarno did in the Fifties, after which this delicious fried rice began to be prepared in many different ways, becoming a must for all visitors.

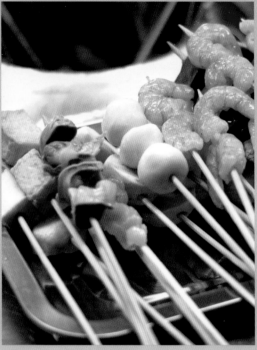

Satay

It seems that its adopted homeland is Singapore, but *satay*, known under a variety of local names, is a delicious common dish throughout much of Asia. It is also a specialty of Indonesia, where it probably originated and is prepared in numerous versions.

Ingredients (serves 4):

1 lb 2 oz of chicken breasts, 5 tbsp soy sauce, 3 tbsp tomato purée, 3 garlic cloves, ground cumin, 4 tsp peanut oil, freshly ground black pepper, 1/4 cup chopped onion, 1 cup water, 3/4 cup peanut butter, 2 tbsp sugar, 4 tsp lemon juice

Put 3 tbsp of soy sauce, the tomato purée, two crushed cloves of garlic, the cumin, freshly ground black pepper, and the peanut oil in a bowl. Stir to blend. Bone the chicken breast, cut it into cubes and put them in the marinade. Cover the bowl and put it in the refrigerator to marinate for at least 30 minutes. To make the peanut sauce, chop the onion and a clove of garlic and brown them in a little oil. Add the water, the peanut butter, 2 tbsp of soy sauce, and the sugar. Simmer, stirring constantly to blend all the ingredients. Remove from the burner, add the lemon juice, and set aside. Grease a steak pan or barbecue grill. Drain the chicken and slide the pieces onto steel skewers. Grill for 5 minutes on each side and serve with the peanut sauce.

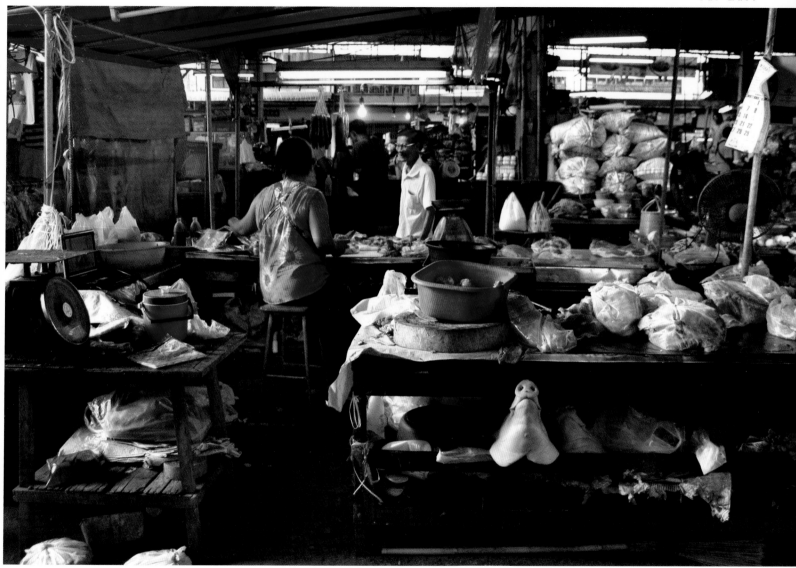

An outdoor butcher on the streets of Bangkok; pork and rice are the most common ingredients of Thai cuisine.

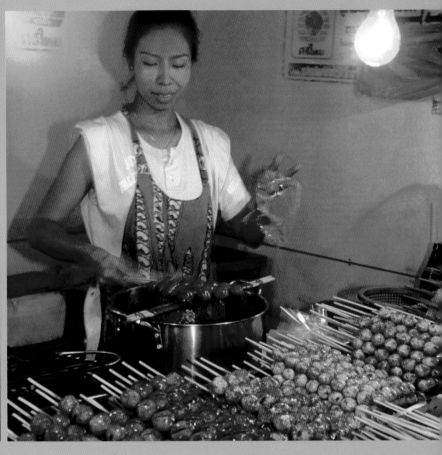

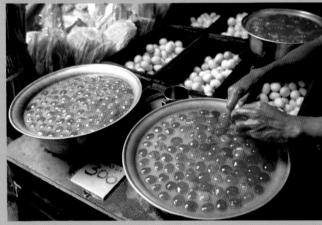

The streets of Bangkok, Thailand

It seems to be a common opinion: Thailand is a gourmet paradise. The capital city is its brightest star, with restaurants famed for their sophisticate cuisine, fusion or Thai.

It is also known for the myriad of proposals crowding its cobbled streets and markets, which are teeming with stands offering spicy salads and yellow curries, and mini-restaurants proffering an infinite variety of dishes, the most popular being meatballs, grilled squid and fried bananas.

The map of the city that eats in the street brings us to its most popular quarters. At Yaowarat, Bangkok's Chinatown, street food is

cheaper, especially at night, when the aficionados of steamed dumplings, bird's-nest soup, rice soup, and Chinese herbal beverages start to arrive.

The side streets — always overflowing with people — are home to kiosks that sell fish and seafood to be enjoyed in the street. And one of the new street-food destinations is equally crowded. It is Narathiwat-Ratchanakharin Road, famous for its small *soi*, which are packed every night with workers and business executives alike. Nevertheless, the rendezvous from sundown until the wee hours is at the fish kiosks near Saladaeng, in the enormously popular area of Silom, the most chaotic in Bangkok, famed for its noodles, rice with roast pork or beef, and wanton. Or along the Chao Phraya, where people eat on the riverbanks. Fried rice, rice fritters, skewers, the freshest seafood, rice with chicken, sukiyaki and *som tam* attract astonishing numbers of people.

Chindia

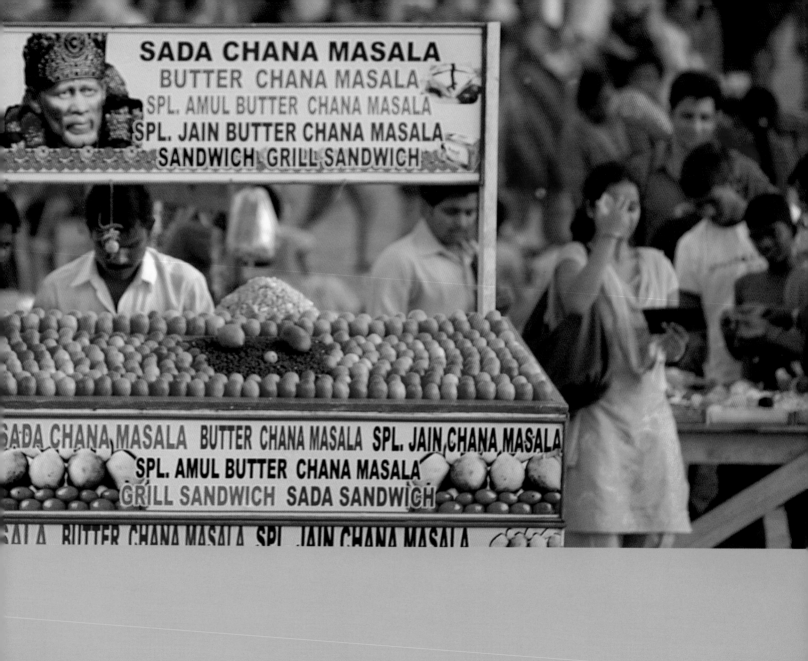

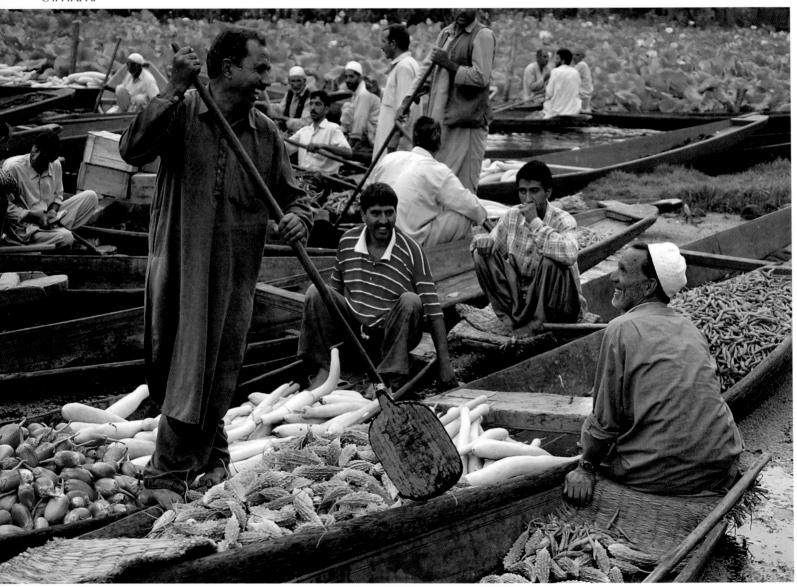

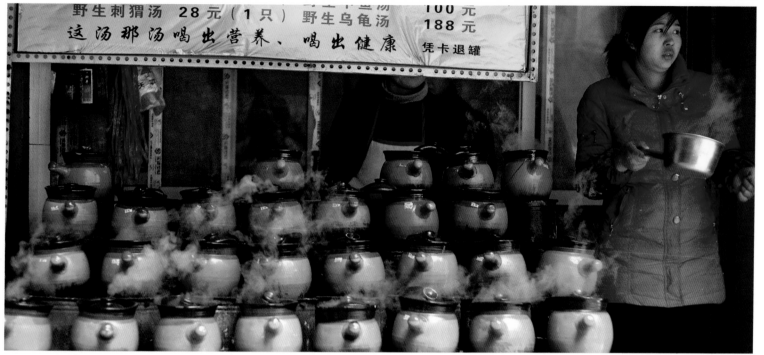

野生刺猬汤 28 元（1 只） 100 元
野生乌龟汤 188 元
这汤那汤喝出营养、喝出健康 凭卡退罐

From p. 120: Snacks on Juhu Beach in Mumbai; the floating market in Srinagar, India; ceramic containers are perfect for keeping soup hot.

The singular proximity of two lands that are home to nearly half of the world population...

China and India represent a variety of faiths, philosophies, and — naturally — a bustling life in their metropolises.

In impossibly crowded streets, people cook and eat. From here, the culinary traditions and exotic scents of curry, masala, and dim sum have spread around the world and become trends in Western cuisine.

What is striking about the menus of Indian restaurants is the enormous array of classic street foods and snacks alongside complete meals, catapulted among these culinary pro-posals straight from the most remote villages. Cheese *naan*, a real treat, is served folded in half at shops that cook outside.

It is the more elaborate version of a flatbread that is served with food to take some of the heat from these spicy, fiery dishes.

Street food in India

Life in the streets of India is full of contrasts, the mirror of the country itself: wealth and poverty, elegant streets and forgotten places. The culinary tradition has circled the globe, creating a fashion even in homes and restaurants. Yet it is only a part of the varied scenario and bustling streets of India. In areas with hot climates food preparation has been inspired by fruit and vegetables, contributing to the variety of regional specialties. Countless food vendors emerge at sunset, symbolizing the contrasts that continue to underpin the fascinating repertory of Indian cuisine.

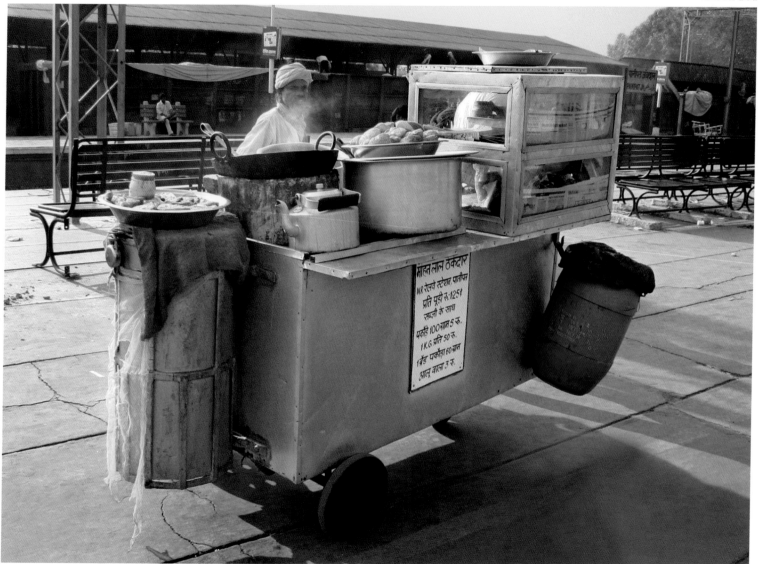

A blend of spices at the Delhi market; a cart with drinks to cool off in the hot Indian weather; a mobile frying stand for *samosas* and other snacks.

Bollywood, Mumbai, India

Though the better-known name of Bombay was abandoned in 1995 for Mumbai, the city continues to be front-page material, above all on literary and film pages. The home of Bollywood — the myth of fame and romantic stories in which love is expressed through scenery, poetry, music, and dance — is also famous for its food. In fact, the first piece of intriguing information perfectly links food and filmmaking, not because of the movie subjects but their duration.

In order to face endless hours at the theater (some films last an entire day), moviegoers often arrive with all sorts of food in tow. They

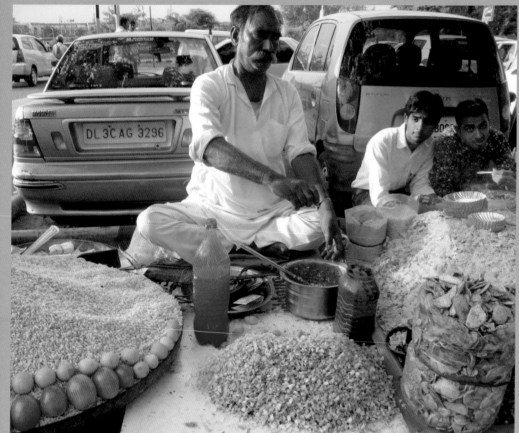

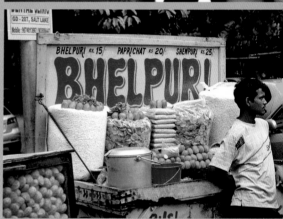

bring it from home or buy it from vendors, above all those hawking *bhel puri*, who lurk everywhere but seem to multiply after sunset, attracting women in colorful saris, children, and visitors. *Bhel puri*, which is made here in the Gujarat style, differs in other parts of India (where it can also have other names).

It is a dish made of puffed rice (actually a type of wheat noodle) blended with spices, tomatoes, onions, potatoes, chutney, hot peppers, and coriander, and served with a sauce of tamarind or lime, salt and chili pepper. Concentrated around the Gateway of India or lined up along Chowpatty Beach, *bhel puri* vendors

alternate with carts offering *pav bhaji*, chopped steamed vegetables served with thin, soft bread. This dish is quite different from *pakora*, made to be eaten on the run. But at the beaches of Mumbai even street food slows down and the pleasure of the sense of taste is augmented by that of sight. And contemplation.

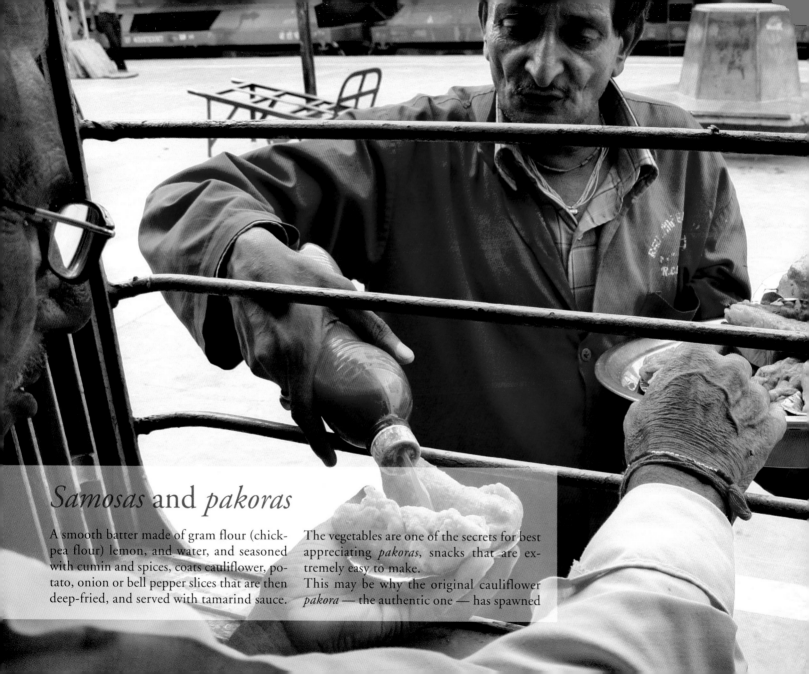

Samosas and pakoras

A smooth batter made of gram flour (chick-pea flour) lemon, and water, and seasoned with cumin and spices, coats cauliflower, potato, onion or bell pepper slices that are then deep-fried, and served with tamarind sauce.

The vegetables are one of the secrets for best appreciating *pakoras*, snacks that are extremely easy to make.

This may be why the original cauliflower *pakora* — the authentic one — has spawned

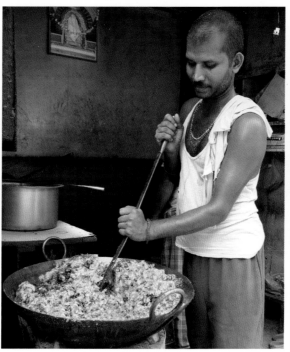

When the train stops, travelers can taste *samosas* through their windows; the preparation of *pakora*.

versions as varied as the faces of India, creating a kaleidoscope of flavors.

Vegetable-filled pastries and frying oil are the essential ingredients of another famous street food: *samosas*.

In the streets of Kenya, on the other side of the Indian Ocean, they are also popular with a meat filling.

Spicier and with a marked curry flavor, these pastries are filled with vegetables that are diced, cooked, and stirred together before being spooned onto thin squares of dough, folded over into triangles, and dropped into a deep fryer.

But the story recounted by *pakoras* is not finished yet and takes us to South Africa, with which India has a unique relationship, as Dutch colonists brought many Indian slaves here in the 18th century.

In many Muslim areas of South Africa *pakoras* are now known as *dhaltjies* and are usually eaten at *iftar* or weddings.

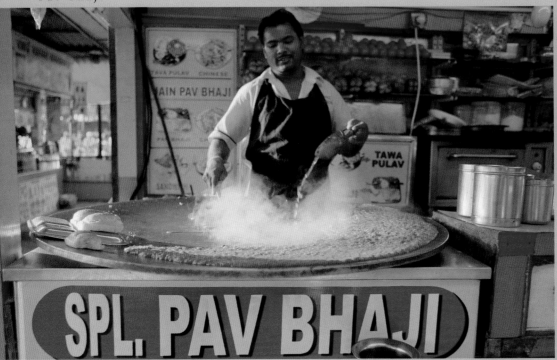
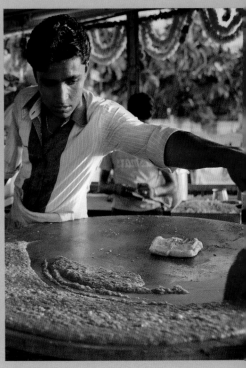

Pav bhaji
It was invented as a meal for the textile workers of old Bombay, who had very little time to eat lunch and did not want a heavy meal, as they had to go back to work. Indeed, its very name reveals its origin. It is a curry and vegetable dish (*bhaji*) served with bread (*pav*, from the Portuguese *pão*) and, in western India it can be found in every street, where it is sold from carts known as *pav bhaji chi gaadi or pav bhaji varo*.

Ingredients (serves 4):
1 cauliflower, 3 potatoes, 1 green pepper, 1 tsp garlic paste, 1 tsp ginger, 1/2 tsp turmeric, chili pepper, 1 tsp tomato paste, 1 tsp *pav bhaji masala*, onions, lemons, soft bread, 1 tsp butter, 2 tbsp oil, salt

Wash the cauliflower and cut it up into florets. Wash and peel the potatoes, and cut them into chunks. Boil the cauliflower and potatoes separately. Chop the green pepper. Heat the oil in a deep pan, and then sauté the pepper with the garlic paste and ginger. Add the turmeric, chili pepper and a pinch of salt; cook for about one minute and add the tomato paste, cauliflower and potatoes with the *pav bhaji masala* and the butter. Simmer until the vegetables have cooked down to a purée. Serve with chopped onions, lemon slices, and pieces of soft bread.

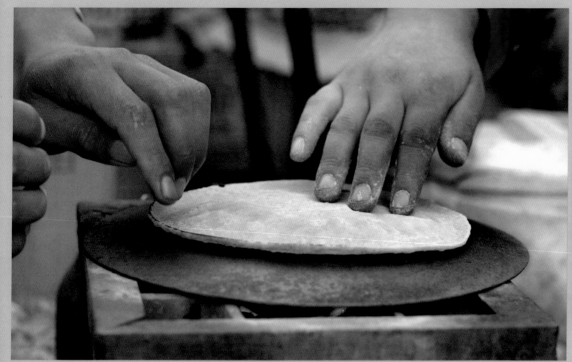

Chapati

This unleavened bread is a tradition in India. Even today some people continue to grind flour by hand to make *chapati*, creating a special and very ancient blend composed of millet, barley, buckwheat, and wheat. Other unleavened breads are *naan*, the *poori*, made of soft wheat, and *roti*, made of red wheat flour or cornmeal.

Ingredients (makes 8):
2 7/8 cup of semolina flour, peanut oil, salt

Mix the flour, salt, oil and a few tablespoons of warm water in a bowl. Stir to blend and add 2 cups of water. Break off pieces of the dough to form balls. Cover them with a tea towel and set aside for 10 minutes. Dredge the balls in the flour, pressing them lightly. Use a rolling pin to roll them out into disks approximately 1/8 inches thick and 4 inches in diameter. Heat the *tawa*, the Indian griddle, or a non-stick skillet, and place the disk on it. Cook the *chapati*, turning it over when it starts to bubble. Turn it constantly, using a rolled dry cloth, until it starts to puff up. Spread both sides with *ghee* (clarified butter). Fold in half and serve in a basket.

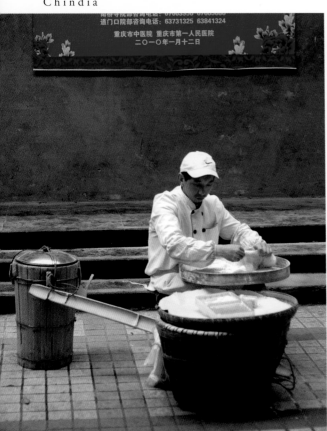

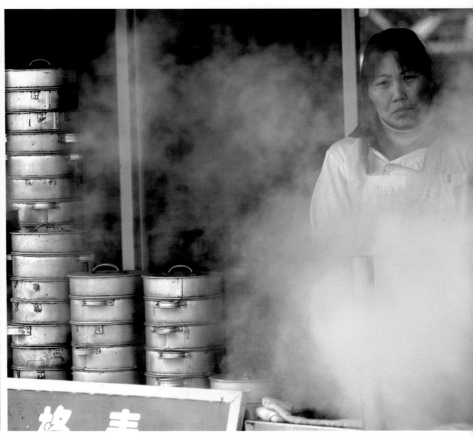

Street food in China

In China, any time is the right time to sit down a full meal or enjoy a nibble. The snacks that are eaten in the street are called *xiaochi*. Cheap and delicious, they are the most picturesque expression of the Chinese culinary culture. Small refreshment stands, often quite rudimentary, nevertheless provide extremely fast and efficient service, offering passersby and travelers a delightful pause. More than a nation, we could call China a continent, the repository of thousands of years of history and the cradle of a culture that boasts the oldest writing system still in use. In the "Middle Kingdom" an astonishing variety of plants and animals has allowed a highly diversified cuisine to develop over the millennia: elaborate and

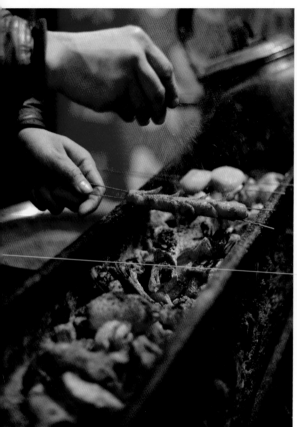

Preparation of *dragon's beard candy*, Chinese cotton candy; *baozi* stand in China; Xinjiang meat skewers; bags of rice at the Wuhan market; a steaming bowl of rice noodles.

frugal, kingly and proletarian. The taste of Chinese food represents a summa of folk simplicity and the varied, refined culture of food, a cuisine in which every ingredient has symbolic value. At neighborhood markets, in highly trafficked areas and in the most inconspicuous alley, life is lived outdoors. The sidewalks are a mosaic of vegetables, extravaganzas of fruit, slaughtered animals, fish darting about in tubs, stands with noodles simmering in broth, steamed dumplings in huge bamboo baskets, colorful flatbread and rolls, skewers of spicy meat, and all sorts of tantalizing delights. It is about the daily focus on life's most elementary need, but it also expresses the authentic flavor of a vital and generous civilization.

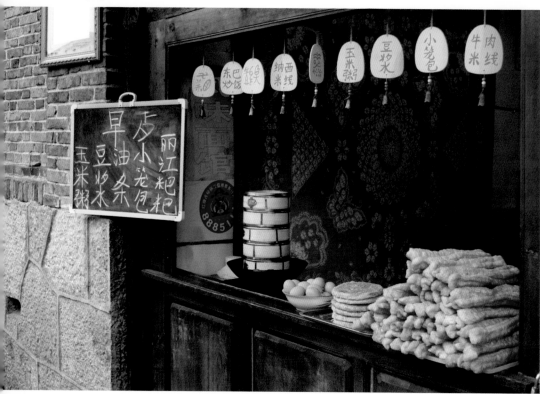

Youtiao, cong you bing (a type of fritter) and eggs that beckon passersby to stop and taste the local specialties.

Youtiao: Chinese breakfast

The morning is the most inviting time to taste the culinary inventions of Chinese street food. The undisputed star at breakfast, *youtiao* are long narrow crullers that are prepared at stands along the streets or in busy areas starting early in the morning. Fried on the spot, they can be re-heated on a griddle set over hot coals, and can be seasoned with spices or dipped in warm soy milk. According to another custom, *youtiao* can be folded and wrapped in a crêpe made of white or black rice flour, heated and spread with peanut sauce or spices.

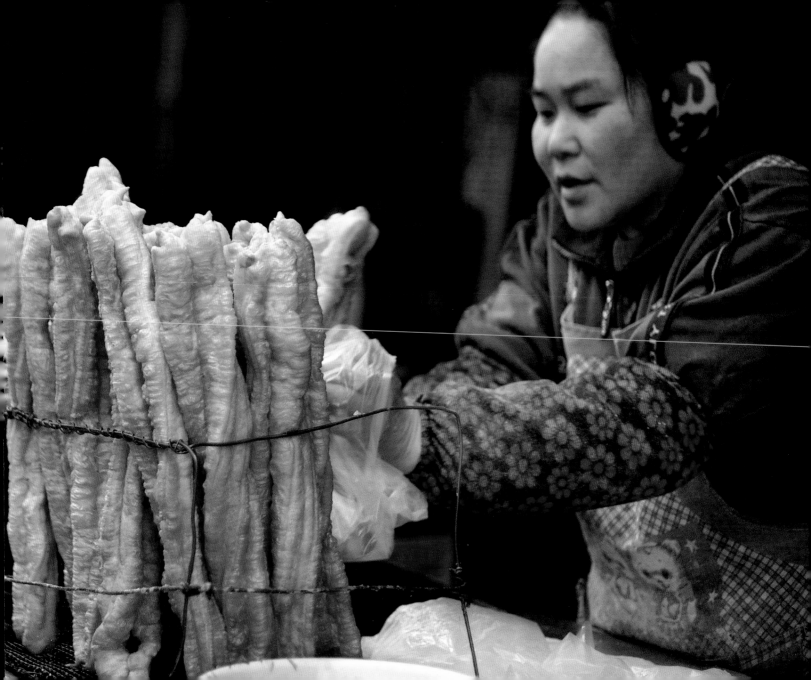

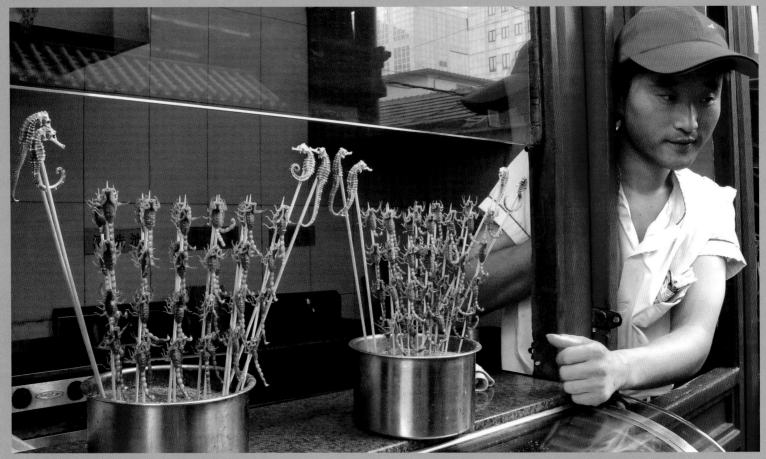

Wang Fu Jing (Wangfujing Market), Beijing, China

The colorful and lively Wang Fu Jing, one of the streets behind the more famous Tiananmen Square, is a must for any visitor. Despite the restyling catering to tourists, the essence of the cult of *xiaochi* is still well preserved and will not disappoint the expecta-

tions of those arriving in Beijing convinced that the Chinese will eat anything that crawls on the surface of the Earth.
In addition to selling conventional skewers of fish and meat, fruit and vegetables, elegant and sophisticated kiosks display insects,

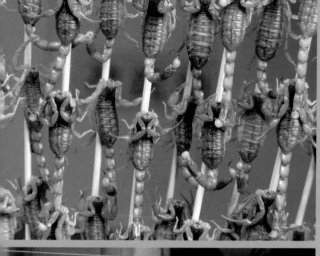

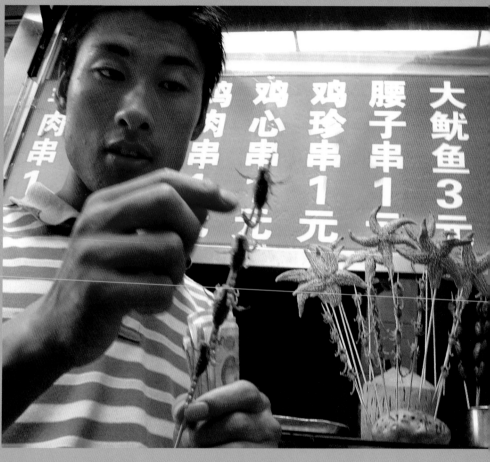

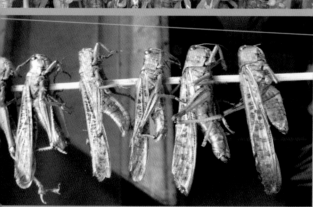

reptiles and critters of all kinds — scorpions, starfish, sea horses, pupas, grasshoppers — fried and threaded onto skewers, ready to be eaten seated comfortably at booths set up in the middle of the street. After all, insects and reptiles are considered delicacies sought after for their therapeutic virtues, in accordance with traditional Chinese medicine.
Restaurants commonly keep live snakes in cages or tanks so that customers can choose the one they want. The hapless reptile is promptly lifted from his sad limbo, decapi- tated, skinned, and cooked at the back of the shop or perhaps even in front of the patron if it is an outdoor eatery.
Snake is a traditional Chinese dish that is served with a distilled spirit flavored with berries and spices.

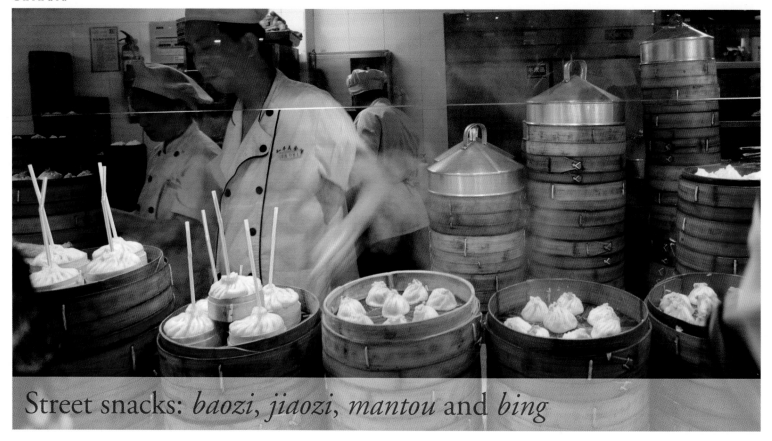

Street snacks: *baozi, jiaozi, mantou* and *bing*

Baozi are sold around the country. You will often find small and simply furnished shops displaying stacks of the steaming baskets used to cook these delicious snacks.

Generally sold by the basket, they are stuffed with various types of vegetables and meats or sweet bean paste.

When eaten on the spot, they are served with a small dish of vinegar or spicy sauce in which they can be dipped using bamboo chopsticks.

Jiaozi — pot stickers or dumplings — have the same filling, but are made using a thin dough of wheat or rice flour.

Mantou, steamed buns that come in various colors and are round or somewhat cube-shaped, are made from a dough prepared with various types of grains.

This Chinese bread is served as an alternative to rice at every meal. White *mantou*, made from wheat flour, is rather delicate,

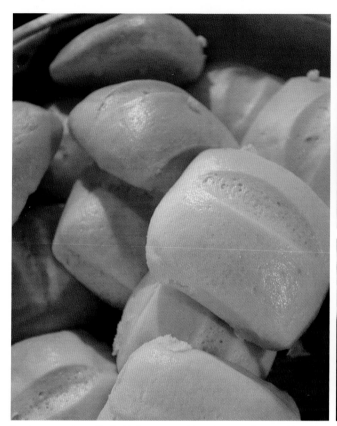

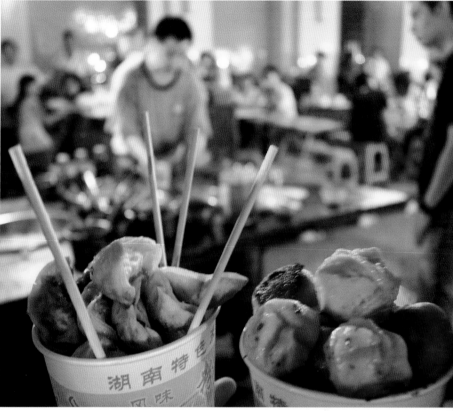

Bamboo containers filled with hot steamed *baozi*; *mantou* (steamed buns); *jiaozi* (dumplings) dressed in soy sauce and eaten with chopsticks, called *kuàizi*.

whereas the kind prepared with different types of grains, such as yellow cornmeal and black rice flour, which has a deep gray hue, are more savory.

Bing — flatbread — is widely known from north to south, and can vary in size and ingredients.

The basic recipe calls for flour, oil or lard, salt, scallions, and pieces of meat or bacon. Cooked on a griddle or sautéed in a little oil, they are a delicious snack to be enjoyed on walks through working-class neighborhoods and in the fleeting atmosphere of the old districts fallen into decay.

At markets and in high-transit areas carts will suddenly appear with a burner, a griddle, and battered but extremely efficient receptacles. At breakfast, you can often find the sweet version of *bing*, made with brown sugar and eggs, or with pumpkin and cornmeal, cooked on a griddle or fried.

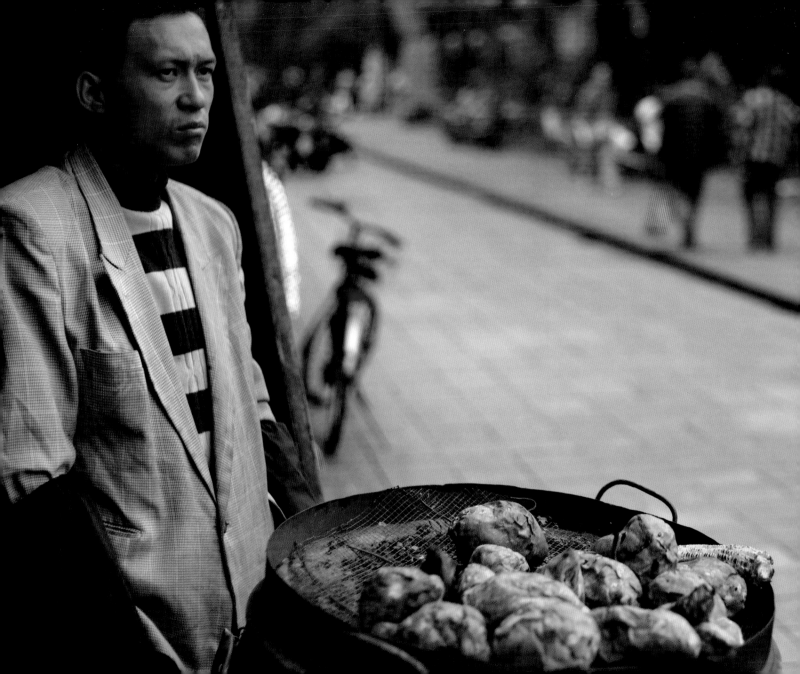

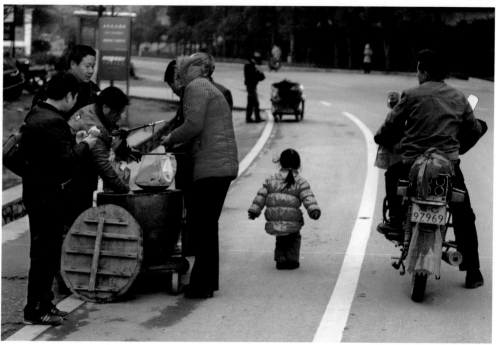

Hot coals used to cook potatoes also heat vendors and passersby on the streets of Chengdu and Shaoshan.

Sweet potatoes baked over coals

During the cold winter months of the north as well as the milder days of the south, the street corners become the haunt of vendors offering sweet potatoes, cooked on rudimentary barrels set on hand-drawn carts.

This authentic feature of rural and popular China tends to be rare in big cities, which are increasingly modern and Westernized. Sweet potatoes are long and lumpy; the coals under the grill wrinkle the dark and uneven skin, revealing the deep yellow-orange color and delicious smell of this generous fruit of the earth. They are sold by weight on rusty and obsolete scales, and are served steaming hot. Once wrapped in sheets of newspaper, they are now tucked into very thin clear plastic bags.

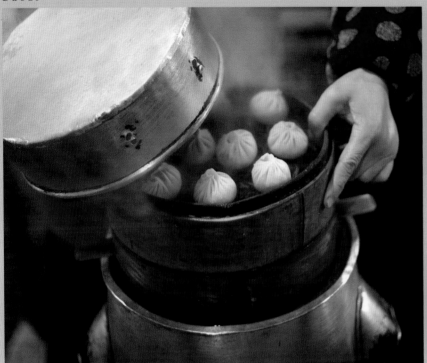
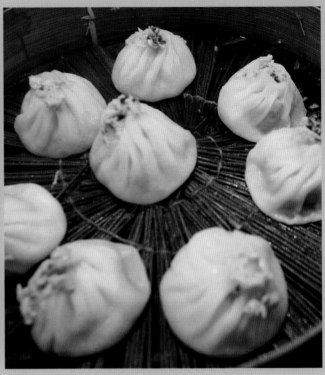

Baozi

These steamed buns, filled with meat or vegetables and steamed, are eaten mainly at breakfast, but also during the day. The streets of China are filled with women selling piping-hot *baozi*, which are transported on carts in large stacked bamboo containers in order to keep them hot.

Ingredients (makes 24):

6 cups pastry flour, 0.9 oz fresh active yeast, 7/8 cup hot water, heaping 3/4 tbsp sugar, 1 egg, 2 2/3 tbsp peanut oil, salt

For the filling: 1 3/4 oz ground pork (or chicken), 1.4 oz red beans (precooked), chopped parsley, 1/2 chopped onion, julienned ginger

Dissolve the yeast and sugar in the water. Prepare the dough with the flour, a pinch of salt, the egg, the oil, and the dissolved yeast. Knead well and set aside for an hour. Knead again and divide the dough into small buns. Put the ingredients for the filling in a bowl and mix well. Flatten the buns, place a tablespoon of the filling in the middle, and then close the dough around them to resemble flower buds. Steam the *baozi* for about 20 minutes.

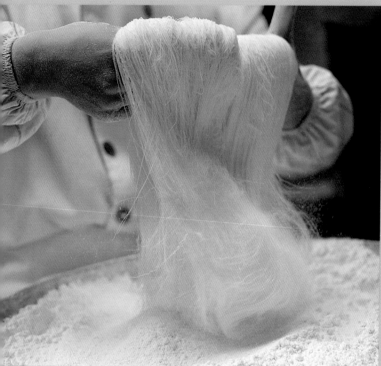

Dragon's beard candy

Also known as *Chinese cotton candy*, according to legend it was invented about 2000 years ago for the emperor himself. It looks like a soft, thin beard — hence its name — as it is composed of very fine threads of sugar. The preparation process is fascinating, so vendors usually make it at their stalls in the street.

Ingredients (makes 6):
1/2 cup sugar, 1/3 cup corn syrup (or glucose syrup), 1/3 cup chopped peanuts, glutinous rice flour

Boil the sugar and corn syrup for about 5 minutes. Cool to room temperature. Repeatedly pull and fold the mixture (it should have an elastic consistency) in order to increase the number of sugar strands that are being formed. To keep them from sticking together, constantly sprinkle them with glutinous rice flour. Cut the "beard" into small pieces and dredge them in chopped peanuts. Serve and eat immediately.

143

America

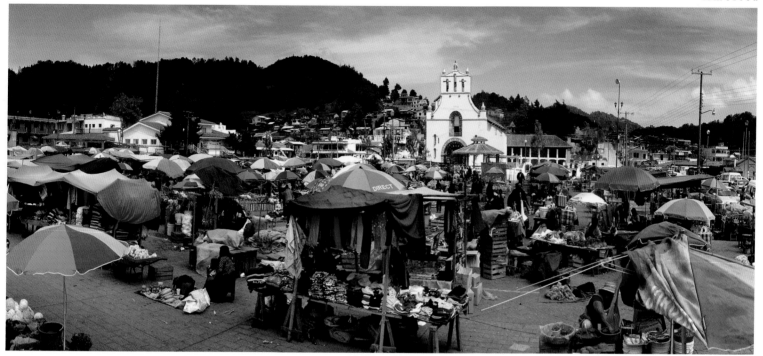

From p. 144: The iconic yellow cabs and glittering lights of Times Square glitter in New York's famous Theatre District; a picturesque market at Saint Juan Chamula, Chiapas, Mexico.

America, or rather, the Americas: strictly plural, like their plural worlds...

When you're in North America, it's like being in the middle of a bright and colorful picture.

The blue sky is mirrored by the glass façades of the skyscrapers and everywhere you go European influences go hand in hand with modern structures. The culinary offerings of North American cities are equally full of contrasts, and you can literally find everything here, from Chinese food to Italian delicacies and organic products.

In South America the luminous sky is like a magnet attracting scents and colors, acting as the perfect backdrop for everyday life, most of which spent outdoors. The smell of food is all-pervasive in South America, where it fills the streets and entices passersby, while it is more subdued in North America, where it plays a supporting role as a time filler, a break from work and a digression. There are few traces here of the

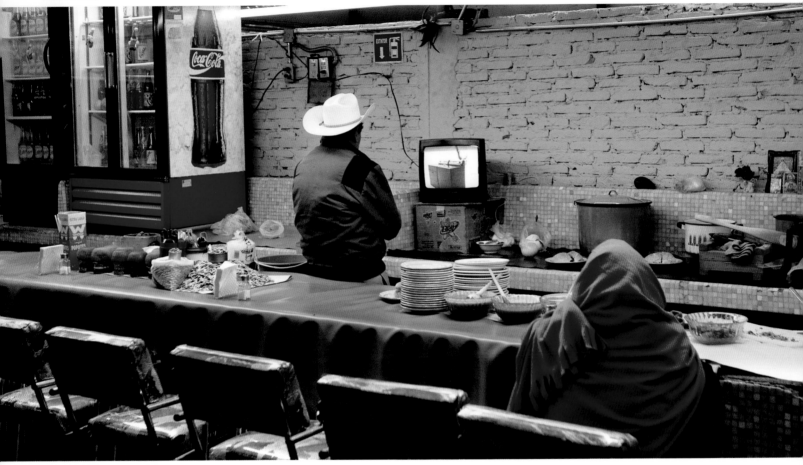

Puebla: around the *zocalo*, the heart of Mexican villages, a patio becomes an impromptu restaurant. All it takes is a table and a few pots.

distant past — inversely there are countless traces of the more recent one, starting in the 19th century, when Europeans and Africans migrated to the Americas, some forced to flee their home-lands and others sent there. All of this is evident in the streets of the Americas. It is part of the language and can be tasted at the table. Or in the streets, where people cook and eat, a habit that has become part of the local mindset. New York would not be New York without hot-dog carts, with their welcoming umbrellas and puffs of steam. Just like the yellow cabs of the Big Apple,

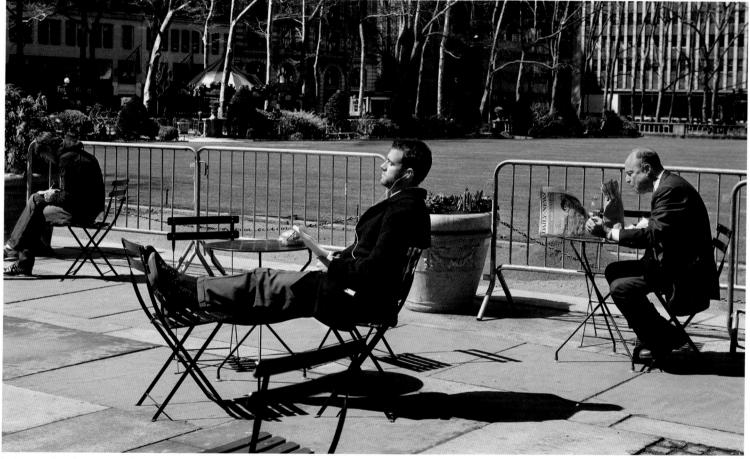

In the great American metropolises, when the weather turns warm people have lunch in streets, parks, and gardens, using folding tables and chairs.

they are part of city life for residents and tourists alike. Likewise, Mexico would not be Mexico without its *burrito* carts, which offer respite to customers in the shade of gigantic versions of the traditional gaily colored *sombrero*. Regardless of whether you're sitting on a park bench reading a book, listening to music to take a break from work and clear your head, or standing by a big umbrella where someone is rolling up enchiladas, food becomes place and places make room for food. And it is in this particular aspect that the thousands of Americas become one.

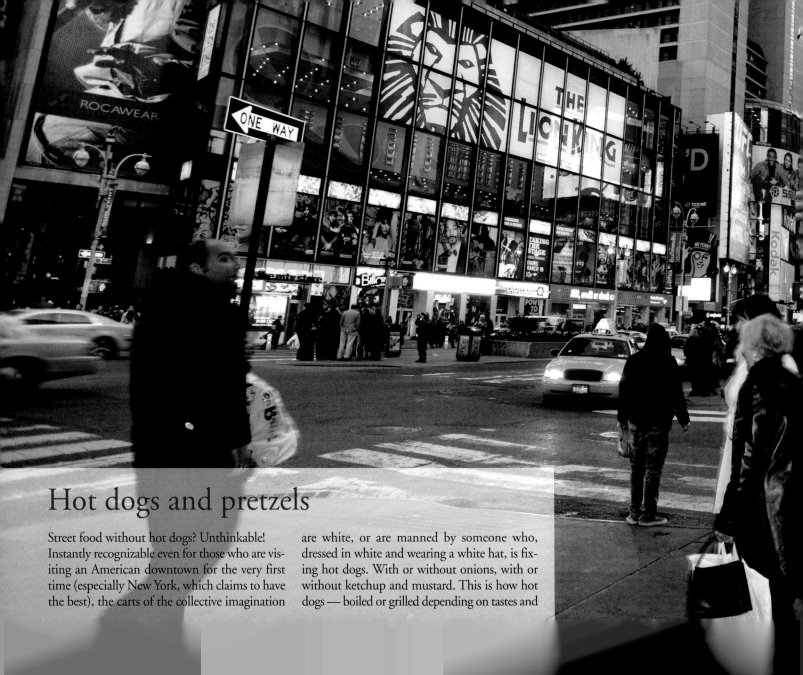

Hot dogs and pretzels

Street food without hot dogs? Unthinkable! Instantly recognizable even for those who are visiting an American downtown for the very first time (especially New York, which claims to have the best), the carts of the collective imagination are white, or are manned by someone who, dressed in white and wearing a white hat, is fixing hot dogs. With or without onions, with or without ketchup and mustard. This is how hot dogs — boiled or grilled depending on tastes and

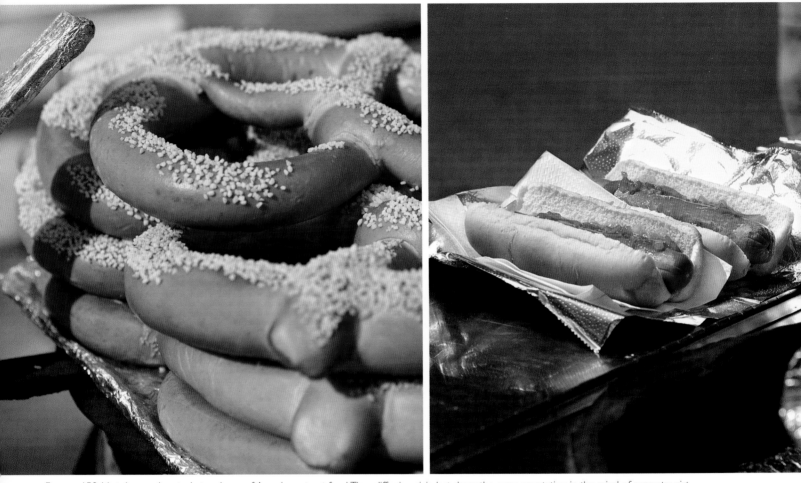

From p. 150: Hot dogs and pretzels: two icons of American street food. They differ in origin but share the same reputation in the mind of every tourist.

needs — are served on a bun. Among Americans, rumor has it that hot dogs taste better in a baguette. Though purists may scoff at the idea, some people offer hot dogs made with meat from organic farms (that's right, even hot dogs have gone organic), served on French bread that is toasted on the inside the way it's done in France, by sliding half a baguette onto a hot spit. But that's another story. In any case, the star is al-

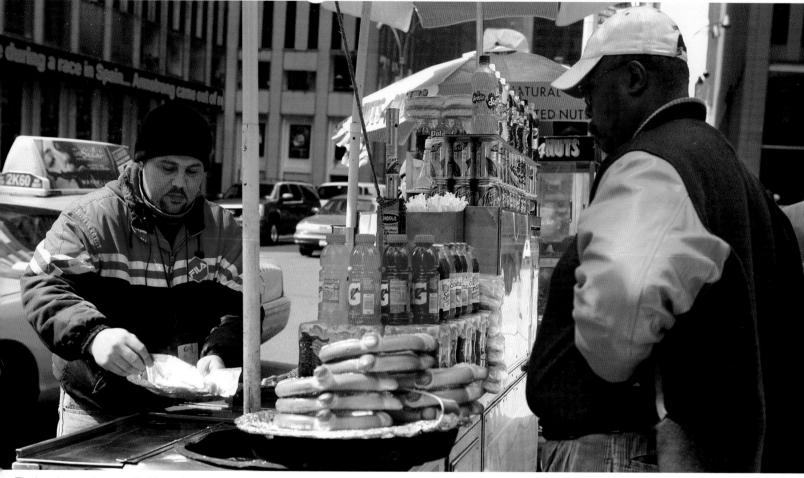

The hot-dog cart is an unmissable rendezvous at any time of the day.

ways the same: the frankfurter, long and slender, and thus depicted as a dachshund between two slices of bread by a witty cartoonist at the turn of the 20th century. If you're still not sated after your hot dog, then you can head over to carts offering another specialty: pretzels, which looked like a flattened figure eight. Sprinkled with coarse salt, this finger food can be eaten neatly as you head on your way.

Blueberry muffins

Blueberry muffins are a classic, but muffins are also made with an infinite variety of ingredients: apples, chocolate, cornmeal, and more. All of them beckon passersby from the windows of bakeries across North America.

Ingredients (makes 12):
3 7/8 cups all-purpose flour, 1 cup of sugar, 3/4 cup butter, 1 1/8 cup milk, 2 eggs, 1 egg yolk, 1 1/2 cup blueberries, 2 tsp baking powder, 1/2 tsp of baking soda, 1 tsp vanilla extract, salt

In a large bowl, cream the butter and sugar for about 5 minutes. In another bowl, whisk the eggs and milk, and then add this mixture to the creamed butter and sugar. Sift together the flour, baking powder, baking soda, and a pinch of salt. Blend until smooth. Stir in the blueberries, setting a few aside as a garnish. Grease and flour muffin tins (or use muffin cups). Spoon the batter into the tins, filling each 3/4 full. Garnish the top with the remaining blueberries. Bake in a preheated oven at 320 °F for 20–25 minutes. When the muffins are done, turn off the oven and leave them in for 5 minutes before serving.

Chocolate chip cookies
Chocolate chip cookies, a classic treat when you're out and about, seem to have been invented in the 1930s by a Massachusetts innkeeper who decided to add bits of chocolate to her traditional cookie dough.

Ingredients (makes 24):
3 3/4 cups all-purpose flour, 1 cup butter, 1 cup sugar, 1 cup brown sugar, 2 eggs, 1 tsp vanilla extract, 1 12-ounce package chocolate chips, 1 cup chopped hazelnuts, 1 tsp baking soda, 2/3 tbsp water, salt

Cream the butter (at room temperature) with the white and brown sugar. Add the eggs one at a time, and then the vanilla extract. Dissolve the baking soda in warm water and add to the mixture with a pinch of salt. Stir in the flour, followed by the chocolate chips and chopped nuts. Drop by spoonfuls on a cookie sheet lined with bakery paper. Bake in a preheated oven at 355 °F for about 10 minutes.

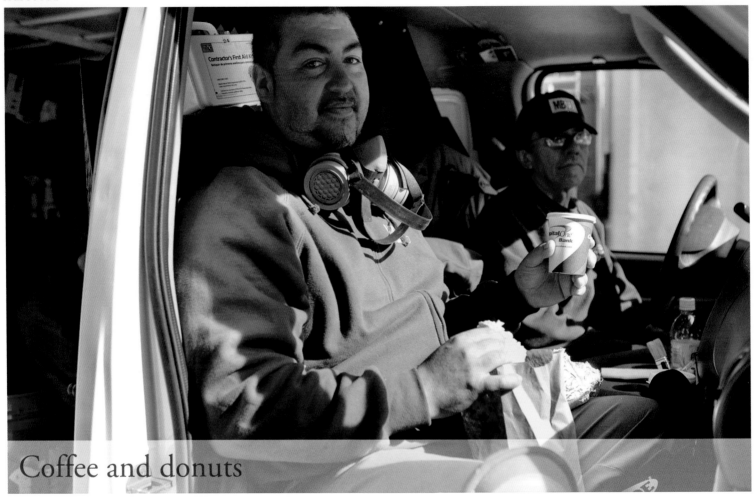

Coffee and donuts

Movie iconography has filled our minds with the images of lawyers laboring into the night over difficult cases, keeping themselves going with a steaming cup of coffee and a donut. Donuts are fried rings of dough dusted with sugar or glazed (chocolate, vanilla, strawberry cream), or flavored with cinnamon, apples or spices. There's nothing new about that, right? Maybe not, but the original idea here is that people even eat the holes!

American television films have made them famous around the world: a cup of coffee and a donut, the joy — and torment — of police officers and ordinary citizens.

There are vendors who fry and sell bags of little cylinders cut from the middle of the ball of dough used to make donuts: hence, donut holes.

They are popular in Canada, where they come in different versions (honey, chocolate, apple, or filled with jam) and they are known as the *timbits*.

In Hawaii they are called *malassada*. Dusted with sugar, holes without donuts and donuts with holes have become one the best-loved snacks.

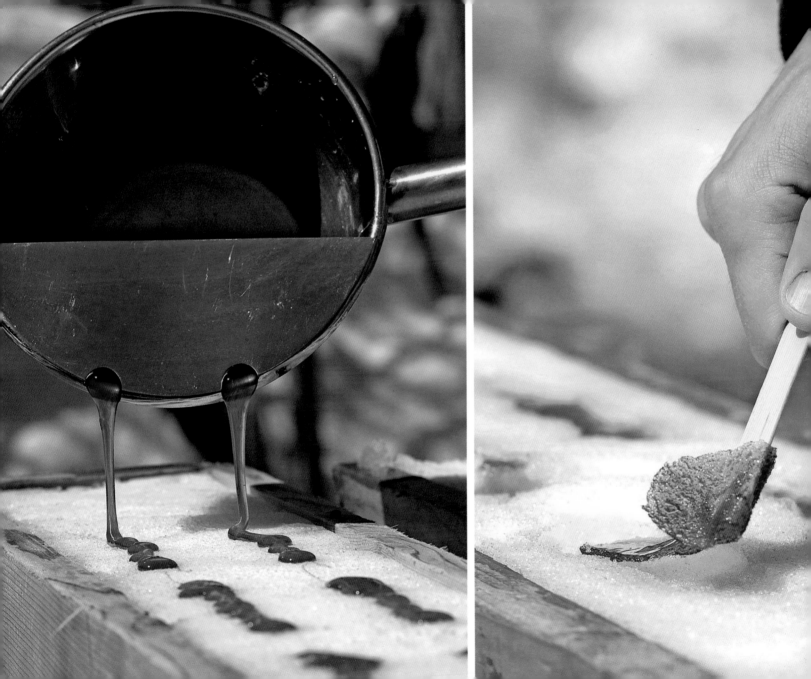

Two stages of the *tire sur la neige*: boiling the sap to make the syrup, and making maple candies.

Quebec, maple on ice

You have to wait for spring to enjoy "sugar time," when what will later become an extraordinary sweet syrup that is surprisingly low in calories is extracted from Canadian maple trees. It is perfect with pancakes at breakfast or with French toast, which — as is often the case — is unknown in the country for which it is named. Originally, however, the Native Americans used it as a condiment for game. But let's get back to maple trees. When the snow starts to melt and the sap runs from the trees, this fragrant nectar leaves the forests of Quebec to circle the globe. Just before the warmth of spring eliminates all traces of snow, it's time for *tire sur la neige*, the taffy-like treat made by dropping the boiling syrup in snow. It is rolled up on wooden sticks, immediately turning it into a unique and little-known "ice cream" that can be enjoyed while out for a stroll or relaxing at *cabanes de sucre*, where maple syrup is prepared to be poured over crêpes and cakes.

New York, Philadelphia, Boston, USA

If you think that a New York train station can't possibly surprise you, try going to Grand Central Station. Here you'll discover the main concourse, the mezzanine, and the underground concourse. In the mezzanine overlooking the main concourse, there is a restaurant with little tables lining the balcony that offers delicious dishes to be savored in the intriguing atmosphere of the hustle and bustle of the station, as loudspeakers announce arriving and departing trains. The scenario changes in the underground concourse, but the purpose of this area — dining — remains the same.

Here you can find the city's most famous oysters, served in a large room close to brightly lit stands heaped with delicious fresh fruit.

Grand Central Station looks like anything but a railroad station, as it seems more like a place to spend a day and not just the time it takes for your train to arrive.

Philadelphia is like nothing you'd ever expect. There it sits, rising over the Delaware, the river of the Indians who originally settled in this territory. You don't expect its redbrick buildings,

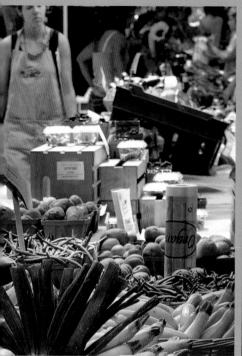

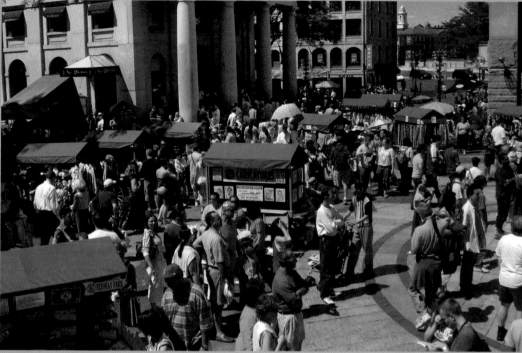

the Liberty Bell that has tolled at all the most important moments in American history, its quaint old houses. And when you cross the threshold of the Reading Terminal Market, built in 1893, you don't expect to find a section with organic food, produced and sold by the Amish, alongside the usual stalls selling fruit and sweets. Around here, the Amish are known as the Pennsylvania Dutch. They sell various products and at the Reading Terminal Market they have even opened an eatery, where you can taste classic blueberry pancakes, apple fritters, and other delights — all strictly homemade.

If you want an international dish but are in an enormous hurry, then Boston's Quincy Market is the place for you. One after the other, you'll find neatly arranged and spotlessly clean kiosks of Indian, Arab, Mexican, American, French, and Italian food under the roof of the old offices of customs agents and sea merchants. Outside, the shops and sidewalk tables are abuzz with the voices of Saturday afternoon crowds. Inside, vendors call out to invite you to taste tandoori chicken, slices of pizza, falafel, baguettes and, above all, lobster. In fact, this is the place that offers the broadest choice of items — edible and otherwise — devoted to the king of shellfish: traditional dishes as well as candies, T-shirts, and stuffed animals.

The best time to visit the market? Between late June and early July, when the events of the Boston Harborfest bring a one-of-a-kind atmosphere to the city.

The world of corn

Quesadilla with *chorizo* and *Oaxaca* cheese, a very common ingredient in tortillas; sweet *tamales* at the market in Cuautinchan, Mexico.

According to a panel at the Archaeological Museum of Mexico City, corn is not the region's oldest "domesticated" plant (in the sense of cultivation), but it is undeniably the cornerstone of its diet and that of the entire South American continent, just as it was during the time of the Aztecs.

Corn is unquestionably king on tables south of the Gulf of Mexico, with the yellow variety, particularly the type grown in Colombia, and the white one, above all in Peru (called *mote*; the type from Cuzco has giant kernels). A trip through cities and villages is all it takes to eliminate any doubt.

In the streets, crisp cornmeal tortillas and soft tacos, tortillas filled and folded in half, are the favorite food of workers who, during their lunch breaks, head to tiny kiosks that spoon out all types of tortilla fillings. A few hours earlier, however, the day began with a breakfast of a steaming, spicy bowl of *chilaquiles*, with fried tortilla chips dipped in tomato sauce.

Also fried but served cold, and thus better suited as an afternoon snack or with an aperitif before dinner, *totopos* (tortilla triangles) are the perfect foil for guacamole, a sauce

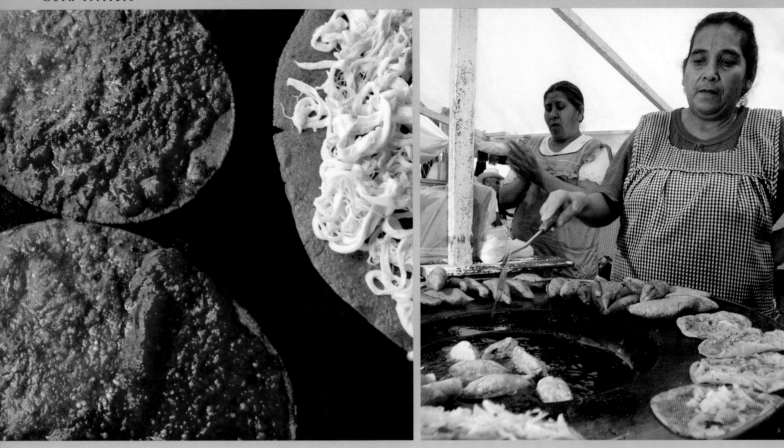

Corn fritters

We're talking about typical soul food, the term applied to the traditional African-American fare that first arose in the American South. To taste it in New York, you need to head up to the streets of Harlem.

Ingredients (makes 12):
3 egg yolks, 2 cups corn kernels, 3/4 cup all-purpose flour, 1/2 cup oil, 1/2 tsp salt, pepper

Using a fork, beat the egg yolks in a large bowl. Add the flour, salt, a pinch of pepper, and the corn. Beat the egg whites until stiff and fold into the corn mixture. Heat the oil in a skillet and drop in the mixture by the spoonful. Fry on both sides until golden.

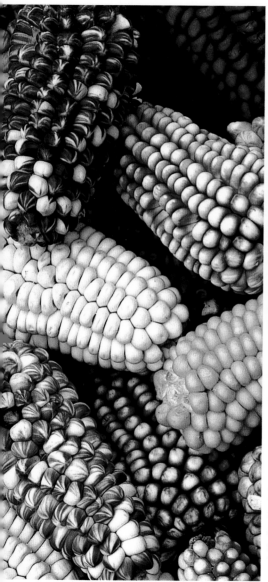

Corn — in every color and shape — is part of the food culture of many Latin American countries.

made of mashed avocado. Corn is also an ingredient in *tamales*, made by wrapping corn dough in corn leaves (a dish also inherited from the Aztec culture), *sopa tarasca* (a spicy soup) typical of Michoacàn, and *gorditas*, small cornbread pockets whose name means "little fat ones" because of the fillings used to stuff them, mouth-watering but very high in calories.

They are made by smiling Mexicans on street corners, and if you're lucky enough you may come across the green kind, made with a special variety of corn.

Street food or underground food?

Beef, pork, chicken, potatoes, fava beans, and corn are some of the most common ingredients of *pachamanca*, offering up the smell of the earth and stones used to cook it.

Its name is composed of two Quechua words: *pacha*, earth, and *manca*, pot.
As the term *pachamanca* implies, this dish typical of the Peruvian Andes is cooked in a pot placed in a hole in the ground and then covered with red-hot lava stones. In fact, it seems that the stones are the secret to this recipe, as they retain heat and then release it slowly. The stones are set on a bonfire for a few hours before being used.

The process is time-consuming, but the taste experience is unique, and as you go around the villages where *pachamanca* is made you can grasp the mystical and cultural meaning that the locals still attribute to food, inter-

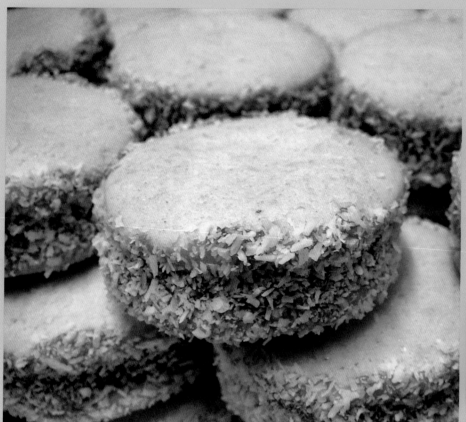

Pão de queijo (cheese buns) Crisp outside and soft inside, these

Brazilian cheese balls are a very popular snack enjoyed around the country. They are also served with tea and coffee.

Ingredients (makes 24):
1 cup milk, 3 eggs, 1/3 cup grated Parmesan cheese, 3 7/8 cup cassava flour, 1/2 cup oil, butter, 1 tsp salt

Warm the milk slightly and pour into a bowl. Add the salt and oil. Whisk the ingredients and then sprinkle in the flour. Add the eggs one at a time, followed by the grated cheese. The dough should be creamy and not too stiff (add more milk if necessary). With greased hands, break off balls measuring about 1 1/2 inches in diameter and place them on a baking sheet lined with bakery paper. Bake in a preheated oven for 30 minutes at 355 °F.

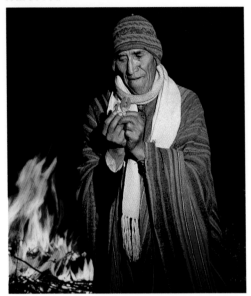

The people of the Andes are known for numerous rituals that pay tribute to Mother Earth, *pachamana* in Quechua, the goddess of fertility who lives in the underworld.

preting cooking in the earth as a way of bringing the ingredients back to their source. To see this event — a veritable street festival — you need to come around March or April, when the harvest is celebrated, or during religious or social celebrations such as weddings and birthdays.

Everyone gets involved: the women prepare the ingredients while the men stack pyramids of stones on the bonfire and dig the hole in which to place the food, which they then cover with damp sacks, earth, leaves, and a cross of flowers.

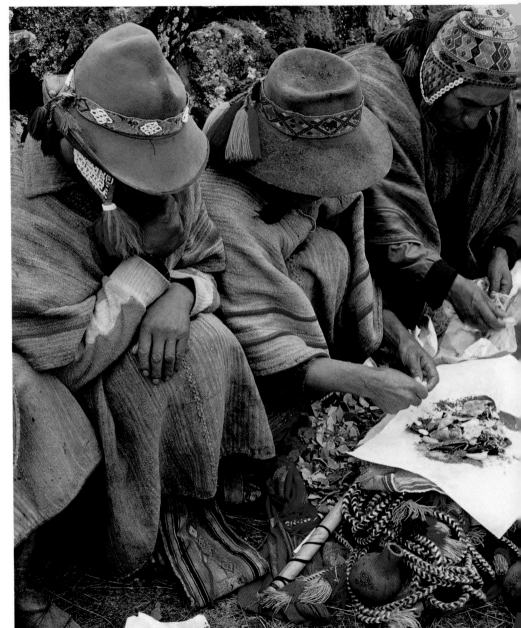

Two *pirulines* vendors offer their colorful delights by their carts or roaming the streets.

¡Lloren chicos!

Cry, children! *¡Lloren chicos, lloren!* Children are bound to cry at the drop of a hat when the reward is so delicious! Carrying a red cylinder with a roulette on top, the vendors of *pirulines* (or *cubanitos* or *barquillos*), cylindrical wafers, walk along the beach and convince children to ask their parents for a coin so they can spin the roulette in the hopes of getting a high number. That's because the number chosen by fate decides the number of *pirulines* they win!

Those with a taste for savory treats should not miss a stroll along the *costanera*: any road that runs alongside a river or the sea.

It's the perfect place to find *carritos de la costanera*, vendors who hawk all sorts of Argentinean street food, ranging from *lomito* to sweet *alfajor*, and from *bolas de fraile* (a type of fritter) to *churros rellenos* or *pastelitos rellenos* (filled pastries) and on to *asado*, the region's typical grilled specialty.

Banan' pesé
Haitian *banan' pesé* are also eaten in other Caribbean countries, where they go by other names. For example, in Cuba they're called *tostones*.

Ingredients (serves 4):
3 green bananas (plantains), frying oil, salt

Peel and slice the bananas. Heat plenty of oil in a skillet and fry the banana slices. Remove with a skimmer and place on paper towels to absorb the excess oil. Mash the fried banana slices with a fork so they look like fritters; there are small wooden boards made especially for this step. Put the mashed bananas back into the boiling oil and cook until crisp and golden. Drain and place on paper towels. Sprinkle with salt before serving.

In the streets of Haiti, women crouch around dark pots, ceaselessly frying *griot* and *banan' pesé*, and the markets abound in bunches of bananas.

Griot, piklis, banan' pesé

These are the only Creole words you need to survive in Haiti. The picturesque food markets are spectacular. Farm women who have walked all night, balancing baskets filled with bunches of carrots and countless other vegetables on their heads, can finally put them down, crouching beside them as they wait for customers to buy *'ti malis* (a slightly spicy sauce), pineapple, and avocado. In the meantime, cooks with colorful kerchiefs on their heads fry *banan' pesé*, mashed bananas, and pieces of pork, called *griot*, made in advance and left to marinate. They are Haiti's two most traditional dishes, and they represent an experience not to be missed, above all in the streets, where the very best can be found. Served on a banana leaf or a paper plate, bananas and pork are served with a very spicy vegetable condiment in brine called *piklis* that will immediately make your eyes water.

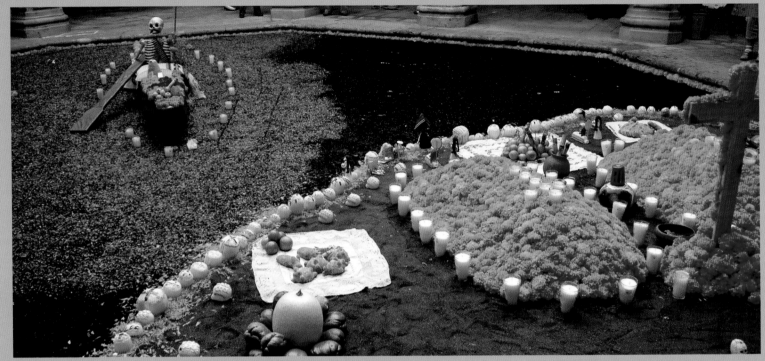

El día de los muertos, Mexico

In Mexico November 2nd is the Day of the Dead. And here it's a celebration. However, the preparation starts earlier, when the rest of the continent to the north is getting ready to celebrate Halloween.

Orange is ubiquitous: the flowers adorning the cemeteries, the little shrines set up on every street corner, the garments on gaily bedecked skeletons and their female version, the Catrinas, set in the windows and squares of every city.

In the courtyards of the ancient palaces that were once the homes of the conquistadors, staircases, banisters, porticos, and flowerbeds are decorated with floral arrangements. Everywhere there is a tribute to those who have passed away, and for whom baskets of fruit and plates of sweets are prepared. At outdoor markets children crowd in front of stands selling decorated sugar or chocolate skulls. In Toluca, behind the cathedral, the sweets market is packed with stalls overflowing with cakes called *borrachitos*, soaked in liquor and thus called "drunkards," and *dulces de muertos*, "sweets of the dead," made chiefly with white or colored sugar shaped into skulls,

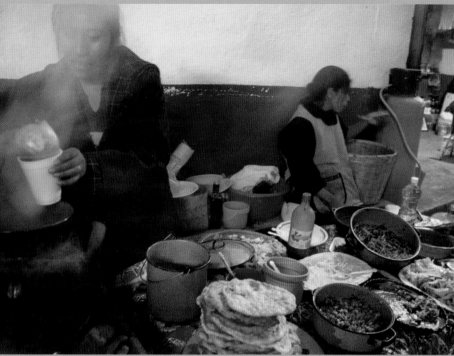

skeletons, coffins, and anything that alludes to death and cemeteries. Unlike it may seem, however, this feast day is a joyous occasion!

The long tables set up under the porticoes of Morelia tell us that this is the perfect place to taste real *comida poblana*, home-style food cooked in huge steaming pots set up in the street. There are no tourists, but there is plenty of music, noise, and candles. If anything, it is an extravaganza of candles, because light is the symbol of the world of the living, as opposed to the darkness of the next life. Candles are set at the cardinal points, candles illuminate the path leading to offerings of food, candles bring the magical flicker of light to this night in Morelia. Naturally, there is water, the symbol of purity. Offered in bowls and even re-created in the form of a lake with blue flower petals, water is an invitation to the returning souls to refresh themselves after the long journey from the afterlife.

It is a journey, at the end of which these spirits find the festivities organized by the living.

It is the scent of flowers that guides the visiting souls on their way, and that is why there are so many blossoms in Morelia, Toluca, and throughout Mexico. At the end of their journey, the spirits find a banquet of fruit and specially prepared foods, but also bread, symbolizing the generosity of those who await their arrival.

Rice, corn, *mole* (various Mexican sauces), cakes, and tidbits accompanied by tequila and mezcal will be their nourishment for an entire year — until the next *día de los muertos*.

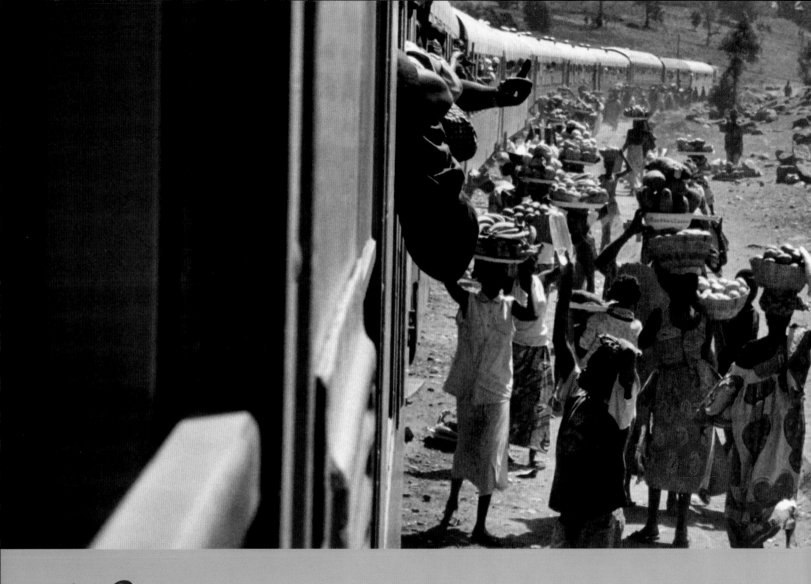

Africa

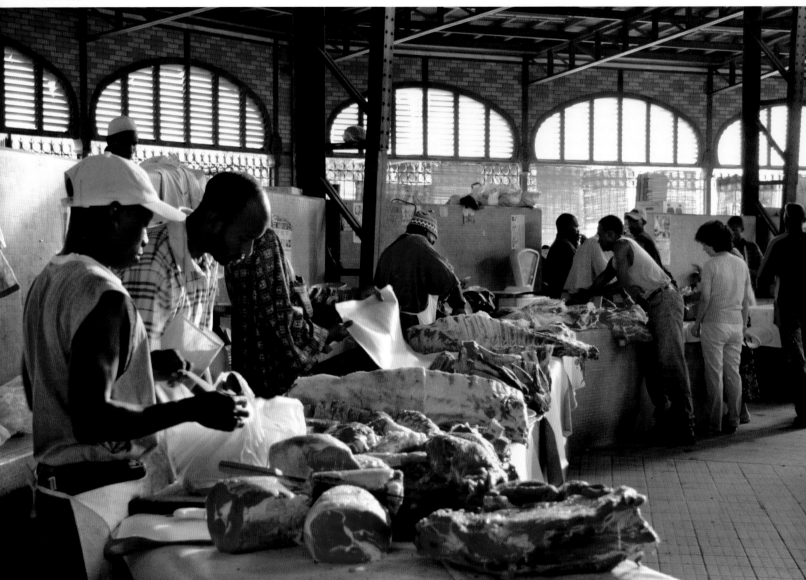

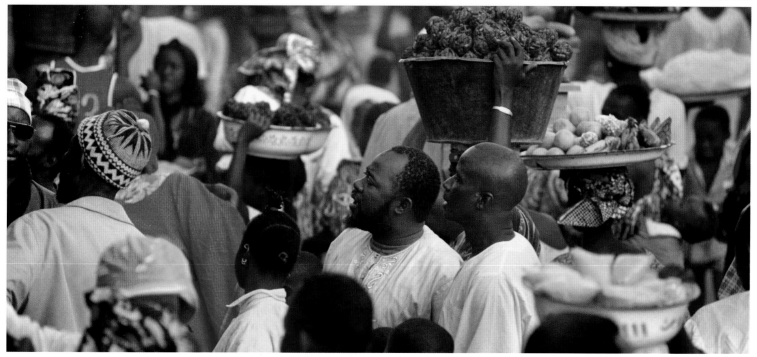

From p. 174: Stop on the Bamako-Dakar train; African markets are a constant melody of people, sounds, smells, and colors.

The land of origins, where space expands and nature reigns supreme.

In the search for the origins of traditional African cuisine, the concept of street food moves into a brand-new dimension. The continent's boundless distances and the nomadic way of life of its inhabitants have come to characterize Africa's culinary culture, more in terms of people's lifestyles than the eating habits developed in a specific geographical area. In these sweeping landscapes, for centuries people have walked along caravan trails, followed the salt route, crossed jungles, and sailed the open seas. Their constant movement — always accompanied by victuals — has introduced African food around the world. The slaves brought to America and then their descendants paid special attention to the traditions and culture of food as symbols of their African identity. We can also find elements and influences of African cuisine gracing the ta-

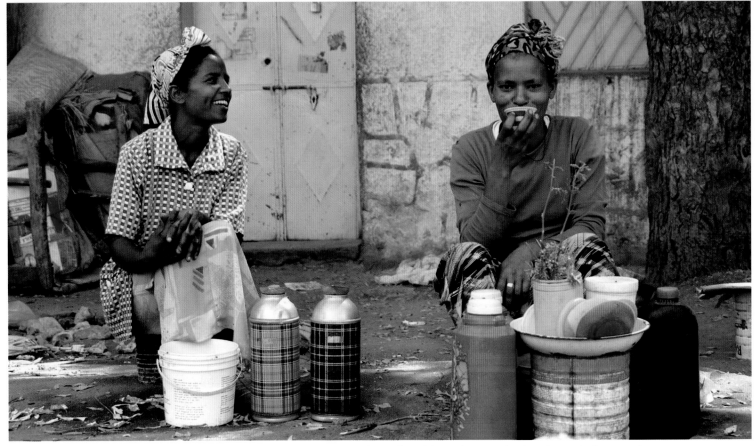

Ethiopia, tea and coffee vendors on a village street. The Ethiopians were the world's first coffee drinkers, a beverage they have known for five centuries.

bles of Brazil and Europe, where couscous and tahini are now common dishes. North Africa, bathed by the Mediterranean, brings us the lively scenario of the market of Homs, near the ancient city of Leptis Magna in Libya, known for its olive oil and food market. Beyond it, the boundaries of the Sahara introduce a new horizon. The traces of these foods fade away as we follow the caravans along routes sketched out in the sand, carrying salt, foods that become increasingly precious in the encroaching emptiness, and dried foods. They cross villages and clank along the railroad tracks stretching from Bamako to Dakar. We find the prelude to Sub-Saharan Africa, on the one hand, and on the other is Nilotic Africa,

Samosa

Very common also in Central and South Asia — notably India — it is a specialty that varies from country to country in size as well as the ingredients of the filling. It calls for numerous spices and can be made with meat or fish, although there are also all-vegetable versions.

Ingredients (makes 80):
1 package puff pastry, 2 lb 2 oz ground lamb (or beef), 6 garlic cloves, 1 knob fresh ginger, 3 sliced onions, 1 tbsp turmeric, 1 tbsp curry, 1 tbsp masala, frying oil, salt and pepper

Peel the ginger and the garlic, and chop them in a food processor. Put them in a bowl with the sliced onions, the meat, and the spices. Blend well. Place the mixture in a non-stick pan (do not add oil) and cook for about 30 minutes, stirring as needed. When the filling is ready, roll out the puff pastry and cut into squares (approximately 4x4 inches). Put a spoonful of filling onto each square and fold to form a triangle. Be sure to seal the edges well. Heat the oil in a skillet and fry the samosas until golden brown. Remove with a skimmer. Place on paper towels to drain any excess oil before serving.

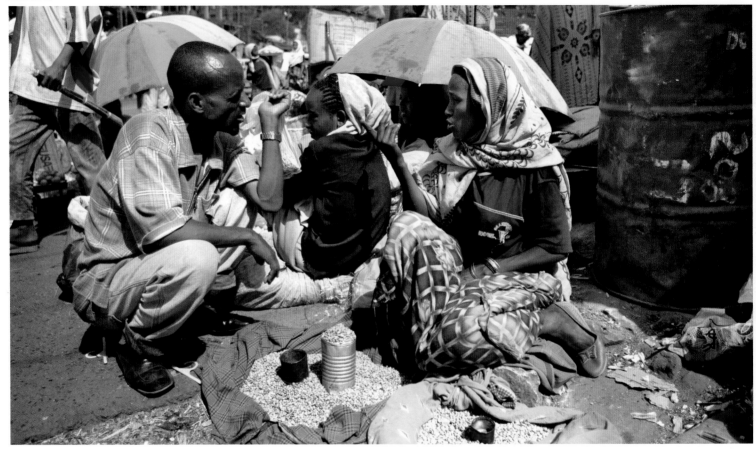

In cities or villages, on asphalt or the dustiest sections of rural areas, in Africa every moment is perfect for offering one's products.

lying along the banks of the great river — the Nile — where time seems to stand still. This lush green strip, a dazzling splash of color against the yellow desert, brings life. Food comes to a stop once more. In front of shops, black metal containers of boiling oil serve up balls of falafel. In the horn-shaped land that extends into the Red Sea, thin sheets of *injera* are wrapped around spicy bits of meat. To the west, the vegetation turns an ever-richer shade of green. Before that, however, are the Bight of Benin and the land of the ancient kingdom of Dahomey, where *klui klui*, sticks of fried peanut butter, are sold and eaten in the streets. Not far away, the chop bars of Nigeria sell *ukwaka*, a

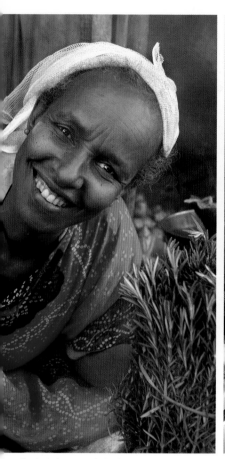
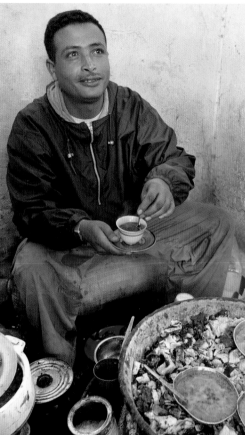
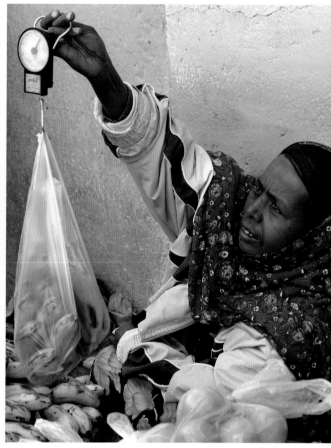

Fresh fruit, aromatic herbs, snacks, desserts, and coffee. The market is not only a place where one can buy things (negotiating the price, of course), but is also a rendezvous.

type of cornmeal porridge, and *moin moin*, balls made of dried fish and beans. The colors of nature turn bolder and brighter, and they appear on women's clothing and dazzling headdresses in shades of yellow, green, and red.

The women rise early in the morning and head to the street with their carts, where they fry cassava, bananas, sweet potatoes, and onion and tomato fritters. These snacks delight children during their mid-morning break at school.

Africa overturns the concept of street food because it has had to adapt it to its very geography. Indeed, this is an immense and varied continent with contrasting yet harmonious facets, a land that is a kaleidoscope of different colors.

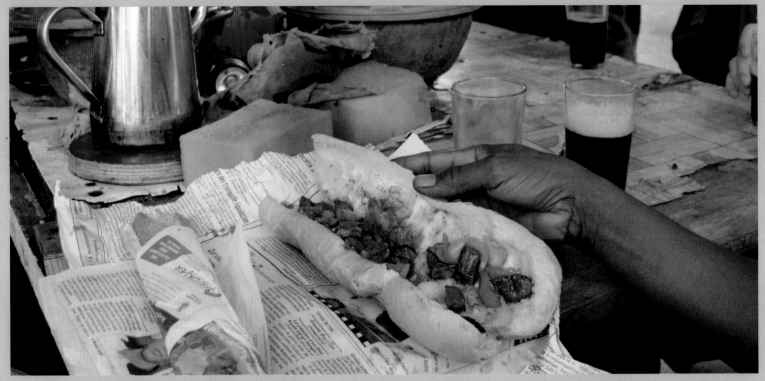

Brochettes

In addition to kebab or *shawarma*, which are extremely popular in African countries, another favorite sandwich is made with brochettes. Along dusty streets awash in sunlight, the grilled brochettes are served on bread that resembles a French baguette rather than pita bread. Marinating the meat is fundamental for making brochettes, and the recipe varies from place to place.

Ingredients (makes 4):
2 lb 2 oz beef or lamb, 1 onion, 1 tomato, baguettes, potatoes, frying oil
For the marinade: diced tomatoes, finely sliced onions and garlic, vinegar, oil, salt and pepper

Place the marinade ingredients in a mortar and mash with a pestle. Cut the meat into small cubes, place in a bowl, cover with the marinade, and refrigerate for several hours. Slide the meat onto steel skewers. Grill both sides. Cut the potatoes and fry them in boiling oil. Slice the bread lengthwise and open. Slide the meat off the skewer and place it on the bread with the fried potatoes. If desired, garnish with diced tomatoes and onion slices.

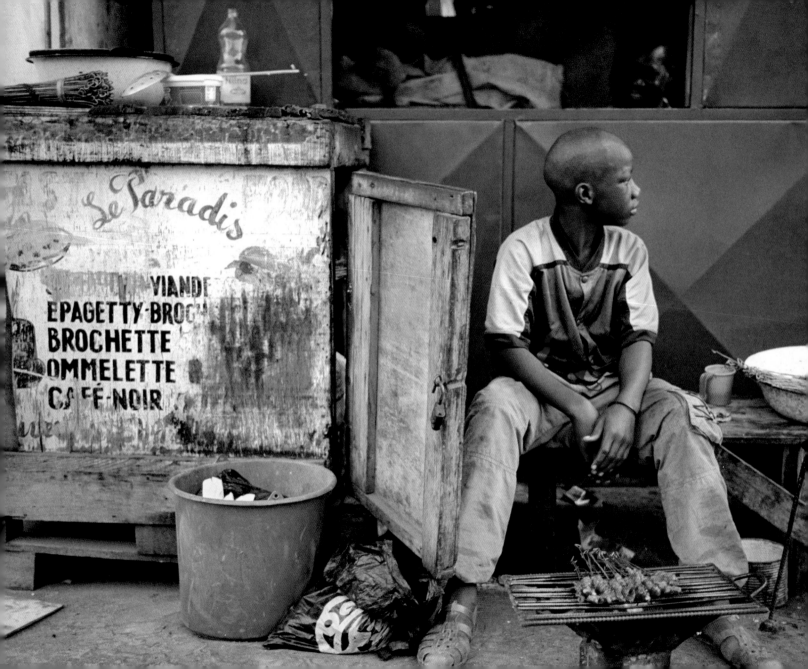

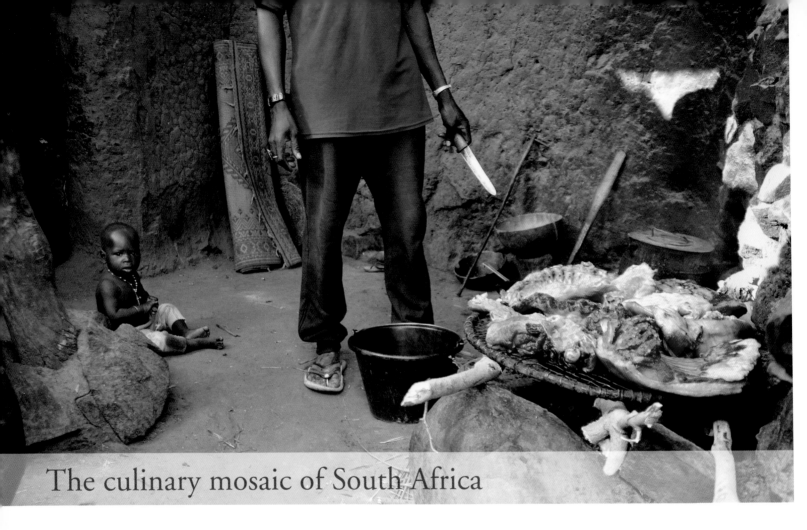

The culinary mosaic of South Africa

Weekends and holidays are time for the *braai*, the barbecue, which represents a true social occasion. At lunchtime, *boerewors* are a ubiquitous presence on red-hot grills everywhere, taking pride of place at all outdoor encounters. These farmer sausages — the name combines the Afrikaans words *boer* (farmer) and *wors* (sausage) — are made of ground meat seasoned with spices dosed according to the butcher's imagination and skill. The mixture is packed into sausage casings, coiled into a spiral, put onto wooden skewers and grilled, and then served on bread. This is how the dish is prepared at the countless street stands that offer delicious sandwiches with grilled sausages every Sunday morning as a popular alternative to the

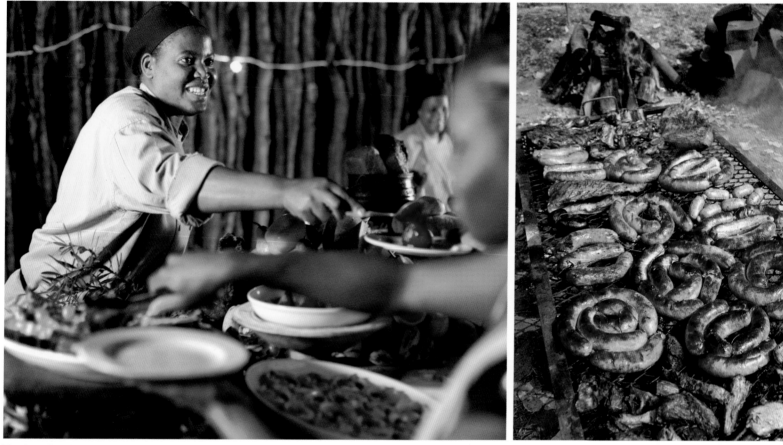

The *braai* (a typical outdoor barbecue) has become widespread throughout South Africa as well as the center of the continent. Today people celebrate National Braai Day.

holiday *braai*. Another favorite South African dish is *bunny chow*, a loaf of bread that is hollowed out and filled with spicy curry. The bread — *bunny* — is an important ingredient, as its consistency is fundamental for bringing out the full flavor of the *chow*, which is spooned into the hole in the middle. It seems that in the early 20th century caddies waiting for golfers at the exit of the Royal Durban Golf Club did not have time to eat a decent midday meal or even get to Grey Street, the haunt of the *banias*, the noontime curry vendors. Therefore, they started to ask if they could bring their food to the golf club entrance; since plastic tubs were not available, the curry was put into large round loaves of bread.

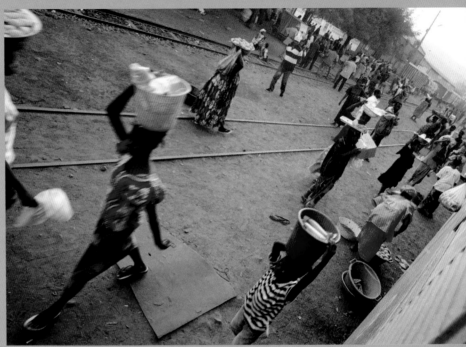

The Bamako-Dakar/Mali-Senegal train

It is the sheer slowness of the ride that represents its unique appeal. The people, the smells, the landscapes moving past at a snail's pace mean that every detail is etched in one's memory, filling the senses. It is a ride that men and women undertake unhurriedly, knowing that the ten intermediate stops might easily prolong it, for it is not a simple journey but an adventure. On the day of departure the Dakar station is bustling with activity. Food vendors hurry to get there and grab the best spots. While street food necessarily awaits the arrival of passersby, on the Bamako-Dakar "express" — a 765-mile journey of 48 hours, though often the time stretches out almost endlessly — the eating experience itself moves along the rails and inside the train cars, and at each stop slender arms shove fruit and food through the open windows. There is food that is ready to eat as soon as the train sets off again, but there are also things to cook once it finally reaches its destination: food prepared during the long hours rolling along the tracks, in the cars where everyone lights his or her own stove to make tea. It is also sold in the corridors of the cars, where vendors hawk dried fruit and nuts: nonstop munching guaranteed!

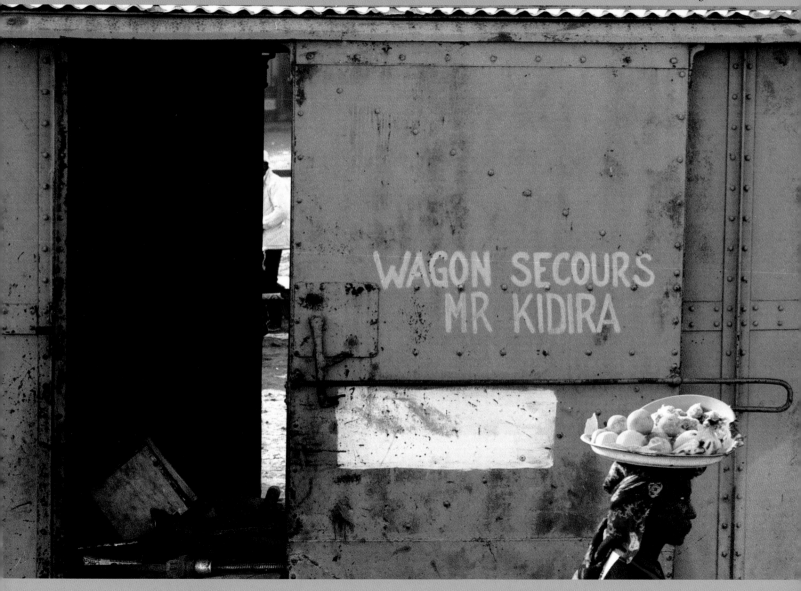

Glossary

Alfajor

Dessert consisting of two (or three) cookie disks layered with thick caramel cream (*dulce de leche*) or jelly, and covered with sugar or chocolate.

Asado

Asado (roast) generally refers to barbecued meat drizzled with an emulsion of oil, vinegar and lemon. Sometimes also dressed with a spice mix. Served with vegetables, which are also often char-grilled.

Bicerin

Another typical Turinese specialty, made with a jealously guarded secret recipe. The name means "little glass" in local dialect. The key ingredients are coffee, heavy cream and chocolate, but the exact amounts are known only by the Caffè al Bicerin, in Turin, where *bicerin* has been served in small glasses since the late 1700s.

Bolas de fraile

In Latin America it may be called a "Berliner" due to its resemblance to *krapfen*. The sweet fried dough balls are filled with custard, *dulce de leche* or jelly, and then sprinkled with confectioner's sugar.

Brik

A typical Tunisian specialty, these parcels are famous for the several layers of feathery phyllo pastry used to make them. They are filled with meat, tuna and vegetables, but there is also a sweet version.

Burritos

Typical Mexican tortillas made with a flour mix and filled with meat, but can also be prepared with rice, chili beans, vegetables, and cheese.

Churros rellenos

A *churro* is a sweet pastry made with flour, sugar, and water. The mixture is then placed in a piping bag and pressed out into grooved strips that are about 4 inches long. It is fried and can be eaten plain or *relleno*, i.e. filled with *dulce de leche*. A delicious sweet accompaniment for a cup of hot chocolate.

Dim sum

Small portions of food served in typical bamboo baskets, often to accompany tea. Originally from China, *dim sum* have now reached the streets of Western cities and are famous from New York to London as a quintessential snack, especially during mid-afternoon coffee breaks.

Enchiladas

The *enchilada* is one of the most famous Mexican recipes, made from a corn tortilla (a thin, round sheet of pastry) covered with meat, cheese or vegetables, then rolled up. It may be fried or oven baked and is usually served (or stuffed) with chili beans and dressed with a spicy sauce. The name comes from the past participle of the Spanish verb *enchilar*, which means "to add hot chili pepper."

Falafel

Croquettes made with chickpeas (or fava beans in some countries) mixed with garlic and onion, fried in plenty of boiling oil, and served in paper cones or in pita bread, accompanied by tahini.

Fritoe

This is the Venetian dialect term for the fritters that are usually made for Carnival. The batter contains flour, sugar, eggs, milk, and yeast, and it is then flavored with lemon or orange peel and stuffed with raisins.

Injera

A typical Ethiopian recipe for soft, spongy bread, ideal for dipping into spicy sauces or as a base for stewed meat.

Koshari

Fast and simple to prepare *koshari* — stir-fried lentils, onions, and rice — is considered the quintessence of Egyptian street food.

Kosher

Kosher (or *kasher*) cuisine or ingredients means everything deemed suitable for consumption by members of the Jewish faith, as established by the Torah. The suitability of the food and its preparation must be certified by competent acknowledged authorities.

Lomito

A soft, sweet bread roll filled with veal steak, lettuce, tomato, mayonnaise, fried egg, and slices of ham and cheese.

Mole

This term, typical of Mexican cuisine, refers to several types of sauces. These sauces are popular at parties and celebrations, with the best-known versions being *guacamole* and *mole poblano*.

Pan bagnat

A typical dish from Southern France, using bread filled with tomatoes, small green peppers, scallions, olives, anchovies or tuna, dressed with plenty of olive oil, basil, and salt and pepper. Some people add artichokes, hard-boiled eggs, and even fava beans. It is mainly a summer dish that is eaten cold. And it's strictly finger food!

Pasta cresciuta
A flour, water, and salt mixture leavened with yeast (hence the term *cresciuta*, from the Italian word for "to grow"). Neapolitan vendors prepare it in balls, fried in boiling oil and served hot.

Pastelitos rellenos
Sweet or savory, as preferred and, naturally, depending on the recipe, *pastelitos* are small parcels stuffed (*rellenos*) with fresh or dried fruit, cheese or creams, and then fried.

Piadina
Thin, round wheat flatbread made with lard or vegetable fat. It is served folded in half and filled with cold cuts and cheese, but can also be made with tomatoes and vegetables. This delicious snack is cooked on traditional earthenware plates and is a famous specialty, especially in the Italian region of Emilia Romagna.

Sciamadde
In the Ligurian dialect *sciamadda* probably means "flame" and refers to the places where savory tortes and baked goods are made and sold. Over the years the *sciamadda* has become a popular haunt for artists and intellectuals, who spend the evening enjoying servings of *farinata* with a glass of wine.

Seven Spices
A blend of spices widely used and sold readymade at supermarkets and grocery stores in the Near East. Although pepper is one of the key ingredients, the rest of the recipe may vary from country to country.

Seltzer
The name given to water with added pressurized gas, used to prepare cocktails and aperitifs. Its odd name derives from the German town of Selters, famous for its mineral waters rich in carbon dioxide and therefore known as *Selterswasser*.

Som Tam
This rather spicy, savory salad combines all the most typical flavors and ingredients of Thai cuisine. It is flavored with lime, chili pepper, fish sauce, and palm sugar, and is served with sticky rice and, in some cases, vegetables.

Spritz
The *spritz* is the most famous aperitif of northeast Italy, where it was invented more than a century ago. The basic ingredients are white wine and seltzer, but the final result depends on the bartender.

Sukiyaki
This Japanese specialty requires lengthy cooking in an iron pot and is ideal in colder weather. The ingredients are sliced beef or pieces of tofu, noodles, vegetables, and a mixture of soy sauce and sugar.

Tahini
Also known as sesame paste or cream, it is made with the toasted seeds and is very popular in the Near East, where it is used as an accompaniment to several dishes or as an ingredient in many recipes, including hummus.

Vermouth
Recognized as a traditional Italian product, this liquor is made by mixing white wine and herbs. It has an alcohol content of about 16%. It was invented in Turin, in 1786, by Antonio Benedetto Carpano and since then has become a famous aperitif, known worldwide.

Wanton
Also called *wonton* or *wontan*, depending on how the word is transcribed from Mandarin. It is a type of dumpling made with disks of dough and stuffed with vegetables, meat or fish (usually shrimp), and then sealed into a triangle or pouch shape. They may be steamed or fried, served alone or in Chinese noodle soups.

Zeppole
Prepared from a dough similar to *pasta cresciuta*, these semi-sweet or sweet fritters are sometimes dusted with sugar. In a number of regional variations, *zeppole* can be shaped like a doughnut, and may be fried or baked. In some cities (like Naples) it is a typical Christmas recipe, while in others (like Rome, where they are called *bignè*) they are prepared for the feast of St. Joseph (March 19).

Photo credits

Fabrizio Esposito: 7, 9, 10-11, 14, 15, 18-19, 21, 23 left, 24, 25 left, 28 top left, 29 right, 32, 33 left, 34 left, 36 left, 38, 39 left, 41, 48 left, 53 right, 55 right, 65, 70 top left, 73, 74 left, 74-75, 75 right, 79 right, 85 right, 105 right, 144-145, 146, 149, 150-151, 152, 153, 154 left, 155, 156, 160 left, 174-175, 177, 186, 187
Fabrizio Esposito (Archivio Lavazza): 16 right, 28 right, 29 left, 68-69, 76-77, 79 left, 80, 86 right, 90 left, 90-91, 93 right, 94 left, 95, 114, 115 left
Andrea Guermani: 6, 122, 148
Andrea Guermani (Archivio Lavazza): 70 bottom left and right, 71, 78, 81, 82, 83, 84-85, 87, 178, 180, 181
Christian Sappà: 12 right, 22 left, 26-27, 31, 72, 86 left, 88 left, 92-93, 98-99, 102-103, 103 right, 118, 119, 126 left
Giorgio Sandrone: 8 left, 123, 132, 133, 134-135, 140-141, 141 right, 142 left, 143
Max Tomasinelli: 44-45, 46, 49, 56-57, 57 right, 58, 60, 61 right
Federico Botta: 13, 25 right, 67, 147, 162, 163, 164
Alberto Ciaravella (Fondazione ArteVision): 30 right, 36 right, 37, 124 right, 126 right, 127 bottom right
Alessandro Capurso (Fondazione ArteVision): 104, 105 left, 107 left, 108, 109, 115, 117
Raffaele Brustia: 124 left, 125, 128-129, 129 left and right, 131
Sigrid Verbert: 20, 33 right, 40, 100 left, 111, 113
Ornella Orlandini: 136, 137, 138, 139, 142 right
Archivio Open Mild Consulting: 158 left, 158-159, 165, 168
Carla Diamanti: 112, 172, 173
Guia Besana (Archivio Lavazza): 8 right, 89, 176, 182, 183
Davide Dutto: 12 left, 154 right, 169 right

Malaysia Tourist Board: 100 right, 101, 107 right
Maria Teresa Dell'Aquila: 17, 23 right, 34-35
Micaela Ballario: 47, 48 right, 61 left
Adeel Halim: 120-121, 130
Andy Holmes (beatdrifter): 62, 63 left
Lucio Beltrami: 16 left, 39 right
Stefano Delmastro: 66, 157
Bergen Tourist Board: 52 right
Carina Esmores: 167 left
Carola Steedman: 167 right
Chiara Ricci: 94 right
Chris Lisley: 127 left
Cristianl: 185 right
Daniel Modell: 63 right
David Glaves: 51 right
Elisa Piccin: 28 bottom left
Fabrizio Di Gennaro: 50-51
Franco Borrelli: 22 right
Izwah Kamal: 116
James & Paula Ronald of Sugar Land, Texas: 161 right
Katrin Jander: 134 left
Luna Guaschino: 97
Massimo Piazzi: 166
Matteo Bertolino: 184
Michael Basu: 127 bottom right
Miriam Mezzera: 88 right
Nicoletta Diamanti: 59 right
Olaf Woldan: 96 right
Paolo Vinai: 64 left
Patrik Olsson: 171 left

Peter Stanford: 52 left
Philadelphia Tourist Board: 160-161
Pia Matikka: 170 left
Raja Islam: 96 left
Ron Reason: 179
San Sebastian Tourist Board: 54
© SATourism Great Stock!: 185 left
Sol Aramendi: 171 right
Stine Fantoft Berg: 64 right
Ted Nigrelli: 170 right
Thelma: 169 left
Valencia Tourist Board: 42
YTL Hotels: 116
Istockphoto: 30 left (narvikk), 43 (ishai01), 53 left (corsicas-mart), 59 left (Zeiss4Me), 81 (MiguelMalo), 110 (sintaro), 159 right (MentalArt)
Fotolia: 55 left (Shtuki Crew)

Cover photo: StockFood GmbH, Munich
Back cover photo (from left to right): Giorgio Sandrone, Federico Botta, Fabrizio Esposito (Archives Lavazza), Fabrizio Esposito, Patrik Olsson

We are especially grateful to: Nicoletta Diamanti; the Tourism Malaysia Office in Milan (www.turismomalesia.it); the Philadelphia Convention & Visitor Bureau in Italy and Spain, c/o Master Consulting in Rome (www.philadelphiausa.travel/it); the Massachusetts Tourist Office in Italy, c/o Thema Nuovi Mondi Srl (www.massvacation.it); the Tourism Authority of Thailand in Italy (www.turismothailandese.it); Ralph Klemp.

Authors

Carla Diamanti

A travel writer and journalist, she is a Personal Travel Designer, and an expert on places and itineraries. She was born in Rome and earned a degree in political science. Diamanti commutes between Turin and Paris, but has lived in the United States, Belgium, and Haiti.

She contributes to Italian tourism magazines, and collaborates with publishing firms, communication studios, and tourism training institutes. She works for major Italian and foreign tour operators as an itinerary planner, cultural assistant, and creator of new tourist products. Her wanderings have yielded fascinating reports, books, photographs, and thrilling and uncommon itineraries.

Fabrizio Esposito

He lives and works in Turin as a professional photographer.

After starting out as a set photographer in advertising, video, theatre and music, now he works on social reportages, and travel and food photography. In the latter field, Esposito has collaborated with figures of the caliber of Ferran Adrià and Carlo Cracco, and with the well-known photographer Bob Noto. Since 2002 he has taught at the European Institute of Design (IED). He also works for important Italian magazines, and photographic and advertising agencies.

His photographs have been published in numerous cookbooks distributed internationally.